BRITAIN IN OLD PHOTOGRAPHS

HAMPSTEAD TO PRIMROSE HILL

MALCOLM J. HOLMES

T0333280

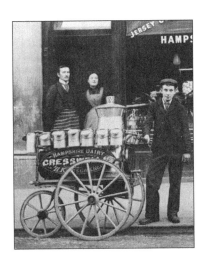

The
History
Press

First published in 1995
This edition first published in 2009
Reprinted 2013

The History Press
The Mill, Brimscombe Port
Stroud, Gloucestershire, GL5 2QG
www.thehistorypress.co.uk

British Library Cataloguing in Publication Data.
A catalogue record for this book is available from the British Library.

ISBN 978 0 7524 5120 6

Typesetting and origination by The History Press
Printed in Great Britain

Contents

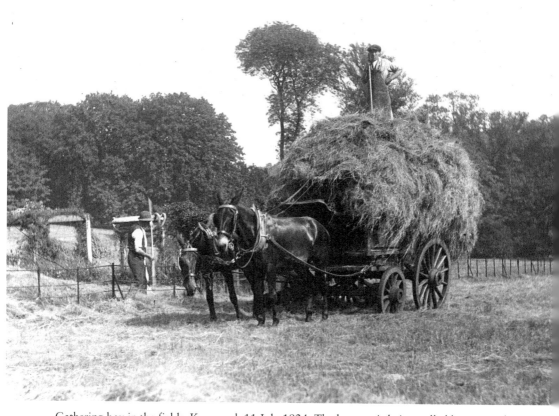

Gathering hay in the fields, Kenwood, 11 July 1924. The haycart is being pulled by two mules.

INTRODUCTION

This book is not intended to be a history of the locality, as many of these already exist, but it is the opportunity to make available a wide range of old photographs and postcards which help capture the atmosphere of the past and record familiar streets and districts as they developed. I hope that it will also encourage readers to explore some of the alleys, steps and corners of Hampstead away from the busy main roads, where less change may have taken place.

Many of the photographs have never before been published and were taken at a time when the high streets were crowded with small shops serving the local population. Included are a fish and chip shop, dairy, cobbler, baker, ironmonger and glimpses of many other ordinary people going about their everyday tasks. At the other end of the social scale, it is possible to see a little of the lifestyle of the more wealthy inhabitants in houses such as Rosslyn House with fourteen servants, or Bellmoor, a palatial mansion occupied by Thomas J. Barratt, businessman and local historian.

Donkey riding, fishing, swimming, farming, fairs and even ski-jumping are just some of the images that have been captured on Hampstead Heath. Parts of the heath have faced many threats: it shrank in size from 1680 until the 1870s but it could have been affected even more drastically as a result of proposals of the Lord of the Manor of Hampstead, Sir Thomas Maryon Wilson. From 1829 onwards he sought to develop his various estates in the locality, including East Park, a wide strip of land to the east of the Vale of Health and the Hampstead Ponds. He also intended to develop Hampstead Heath, over which copyholders and other local inhabitants had certain rights.

He was thwarted in his various attempts to get Bills through Parliament to enable the developments around the heath to proceed, so he began to exert his power in other ways. On parts of open heath he planted thousands of trees, thus changing its appearance. He established a brickfield and constructed a new road to his twenty-eight proposed villas on his East Park estate, erecting a viaduct over swampy land on the route. In evidence he gave to a Select Committee in 1865 he said that if he was frustrated in his development plans he would 'consider the most profitable way of building on Hampstead Heath proper, or the best way of converting it to my own profit'.

His particularly destructive method of achieving profit was to encourage a dramatic increase in the extraction of sand and gravel from the heath. In 1866 he sold rights of extraction around the Spaniards Road to the Midland Railway

Company, which was extending its line to a new terminus at St Pancras. At this part of the heath the layer of Bagshot Sands was at its deepest, and some of the extraction pits were soon as deep as 25 ft as thirty cartloads of sand were removed. Spaniards Road became exposed on a ridge as the land was dug away on either side.

The heath was saved by the Hampstead Heath Act 1871, which led to the acquisition of about 220 acres for public use. Since then gifts and purchases of land have extended it to around 800 acres. One of the most fascinating additions to the heath has been the Pergola Walk and part of the gardens of Inverforth House. The pergola, an 800 ft long structure, is one of the most amazing architectural features in the locality, but is still unknown to many local residents. I have included a scene before it was built and one soon afterwards.

But perhaps some of the most striking pictures are those of the Londoners who flocked to the heath at weekends and Bank Holidays, often as many as 200,000 to 300,000 at a time, to be amused at fairs, in tea-gardens and pubs. The fairs were situated in three areas: during Bank Holidays near East Heath Road and below Spaniards Road, and the more permanent fair in the summer months by the Vale of Health Hotel, later Spencer House. Part of the old fair site next to the Vale of Health Pond closed down in the 1980s and is currently for sale for redevelopment. Declining attendance at the fairs has also resulted in fewer stalls and amusements being set up in recent years.

In many of the pictures horse-drawn buses can be seen, a crucial factor for developing areas such as Swiss Cottage and West Hampstead, where many of the people moving into the large houses were often not carriage owners. A number of areas west of Finchley Road developed first as stabling and garaging for buses before adjacent housing was built. Each horse bus needed a stable of eleven horses, working in rotation. A pair of horses was usually used for each bus, but on steep hills, such as the route up to Hampstead High Street, an extra horse would be added to assist. On the journey down, the well-trained spare horse would trot beside the bus to the foot of the hill.

Finally, where there have been name changes I have generally used a modern name for a street or building to avoid creating confusing or overlong captions.

Malcolm J. Holmes

SECTION ONE

HAMPSTEAD

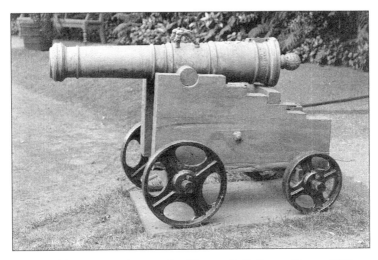

One of the cannon in the grounds of Cannon Hall, Cannon Place, c. 1910.

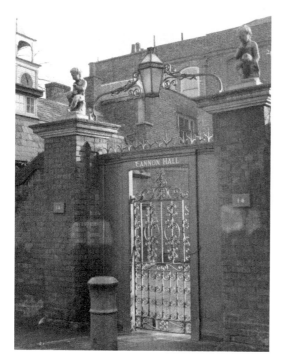

Left: Cannon Hall, Cannon Place, *c.* 1954. It took its name from the pieces of cannon brought back from the East Indies by Sir James Melville, an earlier owner. In the streets outside, real cannon have been used as bollards.

Below: Parish lock-up, Cannon Lane, *c.* 1910. This was built about 1730 into the garden wall of Cannon Hall and prisoners were held in the single cell until transferred. A plaque on the wall was unveiled by Sir David McNee, Metropolitan Police Commissioner, in September 1981.

Right: Perrin's Court, 1954. The road is now pedestrianized and the Villa Bianca restaurant occupies the home of Henry Kippin, chimney sweep, whose sign can just be seen on the right.

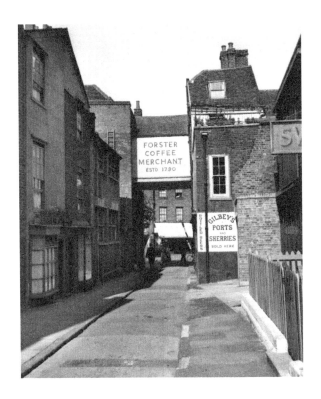

Below: Hampstead High Street and Perrin's Court, 1955. James Forster's high-class grocer's shop is to the left of the archway. The shop had been used as a grocer's since 1774 but traded as Forster's only since about 1885. It closed down in 1975 and David Clulow Opticians now occupies the shop. To its left is the Coffee Cup café, which is still there.

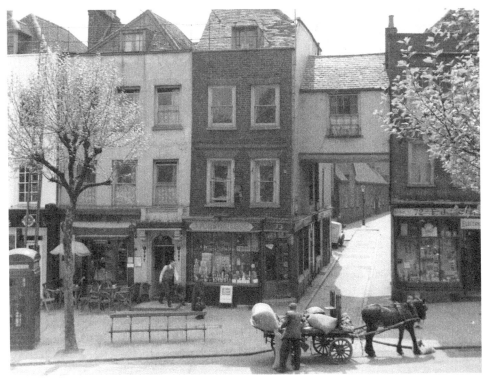

Left: No. 2 Minerva Place, 12 March 1903. It was situated between 48 and 49 Hampstead High Street and was demolished to make way for Hampstead underground station.

Below: Hampstead underground station on Bank Holiday, 6 August 1928. The station and line were opened by David Lloyd George on 22 June 1907 and travel was free the first day, with more than 140,000 people using it. The platforms are the deepest in London, 192 ft below ground.

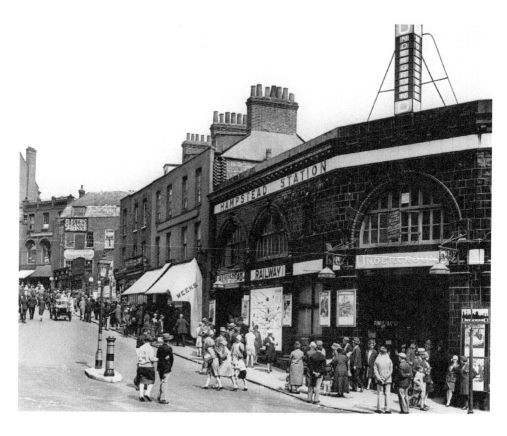

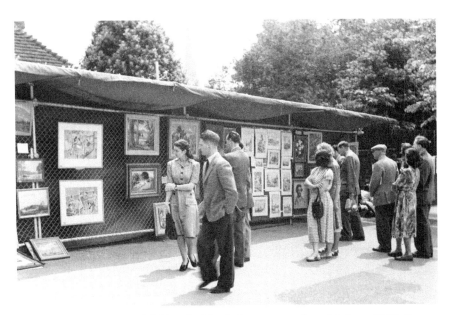

The first open-air art exhibition in Heath Street opened on 18 June 1949. It was held at the top of Heath Street each year at weekends from June to August. In addition to paintings it was possible to buy pottery, sculptures and woodcarvings. It died out after 1983.

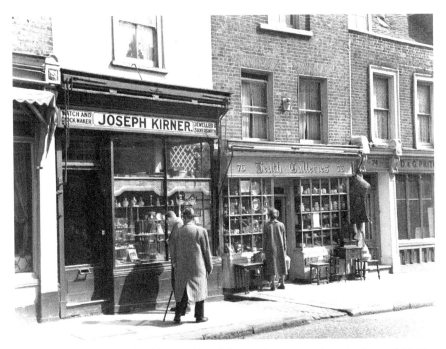

The eighteenth-century buildings of 74–8 Heath Street, seen here in the mid-1950s. The Heath Galleries has been converted into Tabby Cat Lounge; Joseph Kirner, watchmaker, is now California Nail Bar.

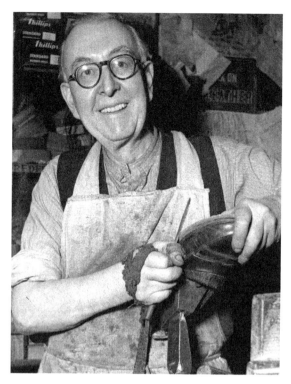

James Burrows at 84 Heath Street in the 1950s. Burrows started repairing shoes in Hampstead at the age of fourteen, and fifty-two years later was still hard at work. Two previous shops of his in New End were bombed in the Second World War and this was his third.

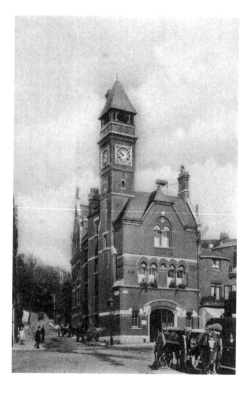

Hampstead Fire Station, 1906. This Gothic-style building, one of the first purpose-built fire stations in London, was opened in 1873. Two horse-drawn engines were kept in readiness for any blaze, and the top of the building was a watch tower with a water reservoir. It closed in 1915. The tower was rebuilt and the ground floor converted into a shop, currently occupied by the Nationwide Building Society.

Left: Golden Yard, off Heath Street, 1954. The name is derived from the Goulding family who dwelt in the yard for about two hundred years. Deeds record that in 1758 the yard had a communal pump and a common 'necessary house' (lavatory) beyond the house on the left.

Below: Nos 53–7 Heath Street, 17 June 1903. The shops have all been rebuilt and Anscombe and Ringland, estate agents, now occupy the premises of Roff and Son, plumber and electrician. Benham & Reeves now to the left and C.E. Ferris now part of HMV shop.

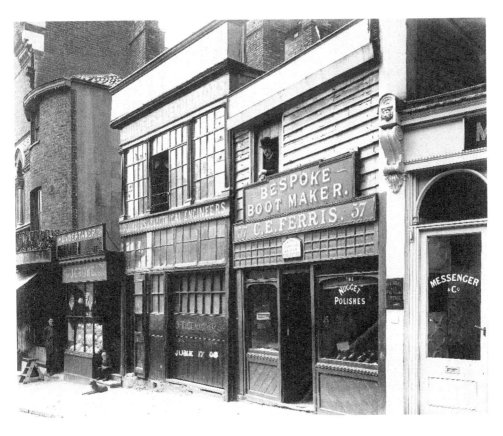

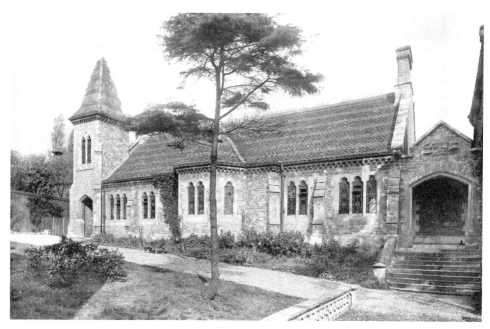

Royal Soldiers' Daughters' Home, *c.* 1890. This moved to Vane House, Rosslyn Hill, in 1858 and started life primarily to house soldiers' daughters orphaned by the Crimean War, training them for domestic service. The main building of the original home has gone but this building still survives and is now used by Fitzjohn's Primary School, Fitzjohn's Avenue.

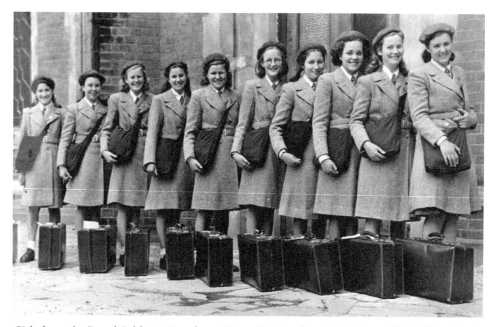

Girls from the Royal Soldiers' Daughters' Home leaving for the holidays, 1950s. The school, now in new premises at 65 Rosslyn Hill, is called The Royal School, Hampstead, and currently has around 250 pupils.

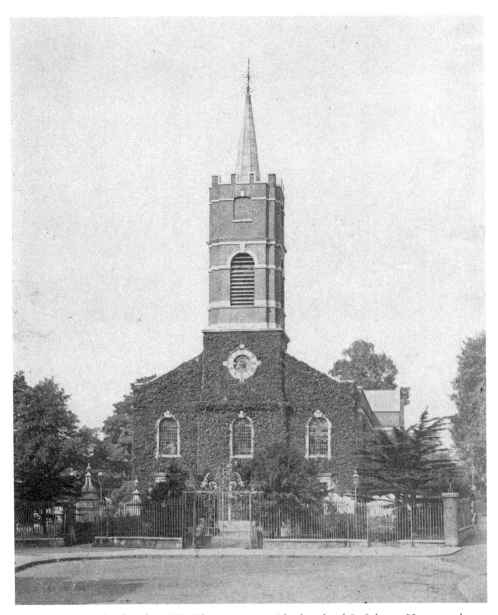

Hampstead Parish Church, 1875. The present parish church of St John-at-Hampstead was built in 1745–7 by John Sanderson, on the site of a medieval church. Additions were made in 1843, when the transepts were added and the church was extended. This photograph was taken when further alterations were proposed, including the demolition of the tower. Fortunately, the tower was saved and the changes by F.P. Cockerell included reorientating the church to an altar at the west end. Amongst those buried in the churchyard are John Constable, artist, Norman Shaw, architect, George du Maurier, artist/author, Hugh Gaitskell, Labour leader and Eleanor Farjeon, children's writer.

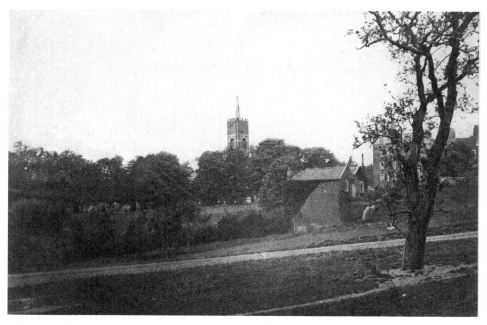

Hampstead Parish Church, 1870. The view is looking north-west from the site of Ellerdale Road and Ellerdale Close towards the church and across the east end of today's Frognal Way. On the right can be seen the backs of the houses on the south side of Church Row.

Church Row, 1846. On the left is part of the terrace of early eighteenth-century houses, one of the showpieces of Hampstead.

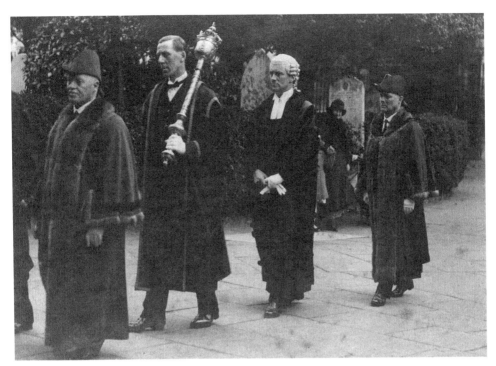

Procession along Church Row to a thanksgiving service at Hampstead Parish Church, part of the Silver Jubilee celebrations of George V, May 1935. The macebearer and town clerk precede the mayor, Councillor B.S. Townroe.

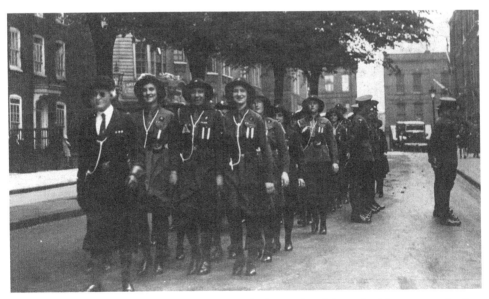

Girl Guides in the Silver Jubilee procession. The borough celebrated with a range of other events, including a searchlight display on Hampstead Heath, free films at the Grange cinema (watched by 2,000 children) and the distribution of Jubilee spoons.

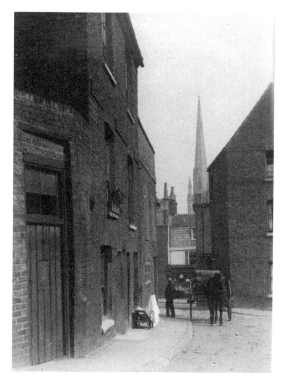

A view of Mount Square, looking east along the north edge of the square to the spire of Christ Church, c. 1900. At this time it was called Golden Square; the name was probably derived, like the nearby Golden Yard, from the local Goulding family. It was renamed in 1937.

Public footpath by Grove Lodge, at the side of Admiral's House, Admiral's Walk, c. 1900. Though the railings are still there, it has now ceased to be a footpath as adjacent properties have built across it. John Galsworthy (1867–1933), novelist and playwright, lived at Grove Lodge from 1918 to 1933.

Streatley Place, off Back Lane, 1954. This corner has been rebuilt as part of no. 2. Some of the old street lights still survive, and have been converted to electricity.

Holly Bush Stairs leading from Heath Street up to Golden Yard and Holly Mount, *c.* 1900. The view has changed very little since and is one of the attractive routes leading away from the busy town centre.

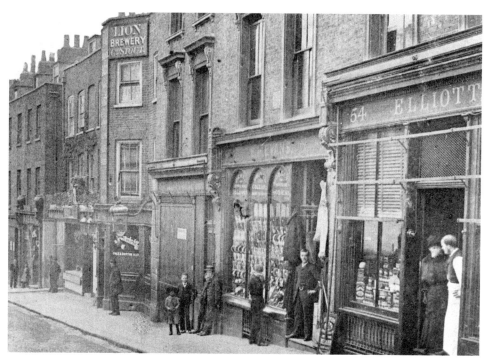

West side of Hampstead High Street, 1883. These shops and the Black Boy and Still pub were swept away by the Hampstead Town Improvements project, which was completed in 1887. Heath Street was extended to the south to join Fitzjohn's Avenue, and the High Street was widened. From the narrow streets, alleys and courts, 246 'persons of the labouring classes' were rehoused.

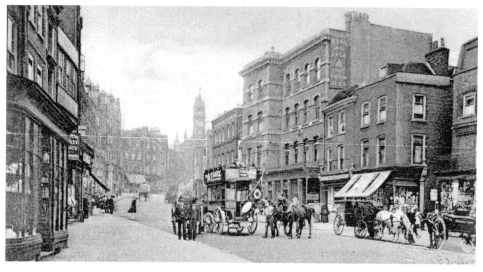

Hampstead High Street, c. 1906. A change of horses has just been brought across from the stabling in Bird in Hand Yard. The Bird in Hand pub, to the right of the horse bus, became the Dome café/bar, and is now Café Rouge.

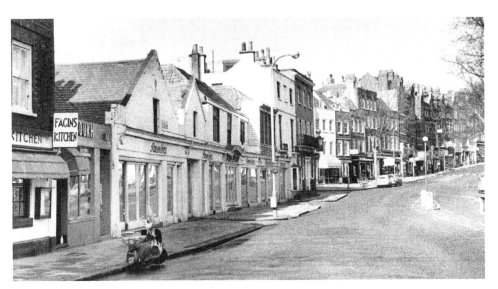

Hampstead High Street, 1950s. Fagin's Kitchen, on the left, is now Goldfish Chinese Restaurant. The *Hampstead and Highgate Express* offices were next, followed by Rowland Smith's motorbike showrooms. The Hampstead post office was built on most of this site in 1973. Next to it Hampstead Community Trust opened a market in 1976 and runs a community centre.

A view up Hampstead High Street in 1946. On the left is now the Coffee Cup café and David Clulow Opticians, before the entrance to Perrin's Court. The area to the right, screened by trees, is where Hillsdown House, Spencer Walk and Café Rouge are now situated.

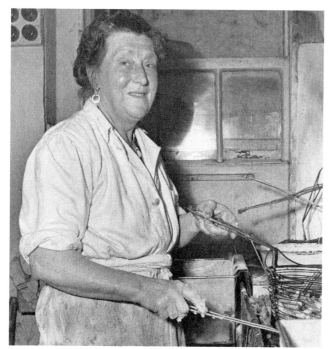

Left: Mrs Ann Taylor preparing fish and chips at her shop in 5–7 Flask Walk in the 1950s. The building had been a fish shop since the 1860s but is now 'enry 'iggins hairdresser and an empty shop.

Below: Flask Walk, 1949. The Flask Walk Pharmacy at no. 1 is now Keith Fawkes bookshop. Ann Taylor's shop, nos 5–7, has a 'Fried fish and chips' sign outside. The street is now pedestrianized.

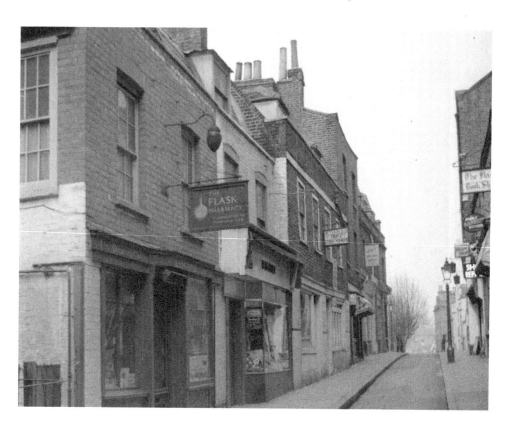

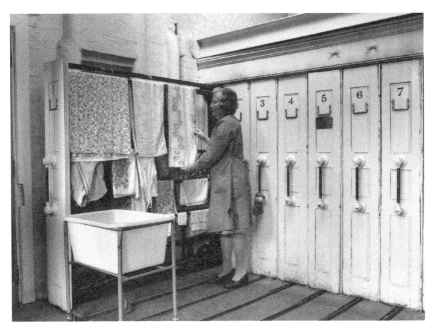

Flask Walk Baths, 31 March 1978. Opened in 1888 by the Wells and Campden Charity at a cost of £4,500, this provided a wash house, laundry and nine hot baths, three first class and six second class. Here is one of the last users of the sixteen drying racks for clothes: the baths closed a day or two later.

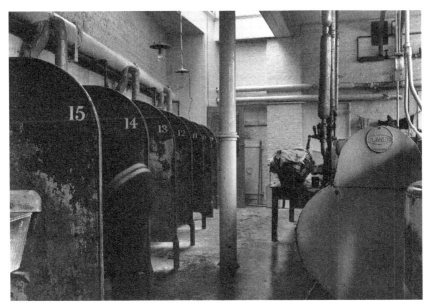

Wash house, Flask Walk Baths, 31 March 1978. The wash room was fitted with sixteen numbered compartments, each consisting of washing and boiling troughs. The building was converted into town houses in 1981 but the 'Baths and Wash House' sign still remains.

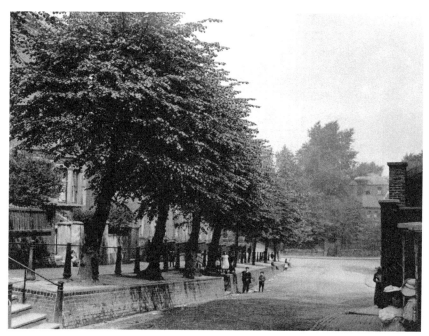

Flask Walk, looking towards Flask Walk Baths, *c.* 1910.

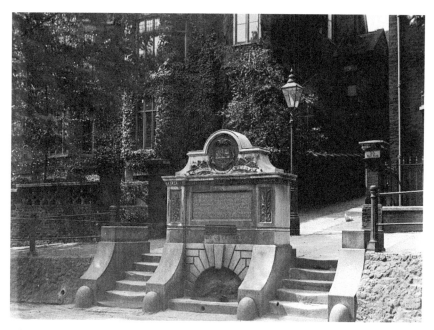

Chalybeate Well, Well Walk, *c.* 1900. It was erected in 1876 to replace an earlier fountain on the opposite side of the road outside the Long Room of Hampstead Wells. The medicinal qualities of the springs attracted many visitors to Hampstead as a spa and place of entertainment. This was a major factor in the early growth and development of the locality.

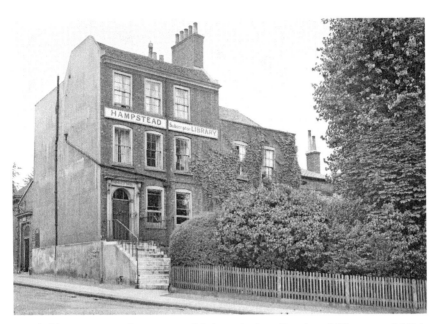

Stanfield House, on the corner of Prince Arthur Road and Hampstead High Street, was named after the artist Clarkson Stanfield who lived here from 1847 to 1865. In 1884 the Hampstead Subscription Library, founded in 1833, moved here. John Constable and the publishers John Murray and Norton Longman, were early shareholders. It once held 6,000 volumes but was closed in 1966.

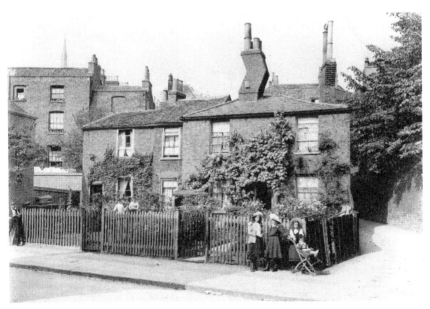

Nos 1–2 Flask Cottages, Flask Walk, 1910. These have changed very little in exterior appearance, although some of the buildings in the background have disappeared. With the growth in the use of central heating, chimneys have often been removed from houses, leaving fewer quaint ones like these.

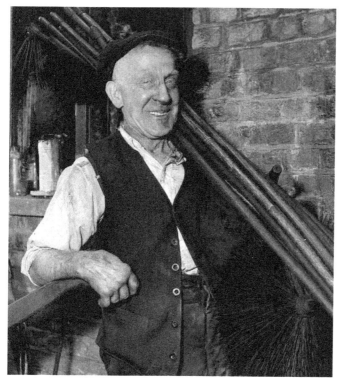

Henry Kippin, of 1 Perrin's Court, 1950s. He was the last of three generations of Kippins who swept Hampstead's chimneys for a hundred years. He died in 1968 aged eighty-six, having put his brushes away only three years before. The hand cart he used to push his poles and brooms from house to house now stands outside Burgh House.

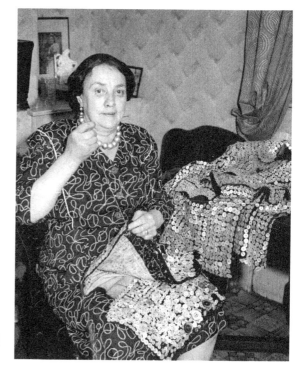

Rebecca Matthews, the Pearly Queen of Hampstead, sews mother-of-pearl buttons on to her costume at her Flask Walk home, 1950s. She worked in the laundry at Flask Walk Baths but in her spare time, together with her husband Bert, the Pearly King and council rat-catcher, she helped raise over £250,000 for charities. Rebecca died in 1963 aged seventy-seven.

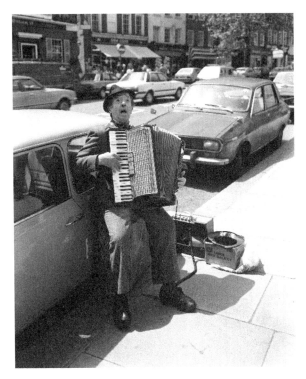

Left: A busker and his accordion entertaining in Hampstead High Street in 1981.

Below: Maggie the flower-seller on the corner of Willoughby Road and Rosslyn Hill. She died in 1974 aged seventy-two, four months after she had retired from her pitch, where she had sold flowers for sixty years. In 1977 a commemorative plaque was erected at this spot by the Heath and Old Hampstead Society, and the corner is now known as Maggie's Corner.

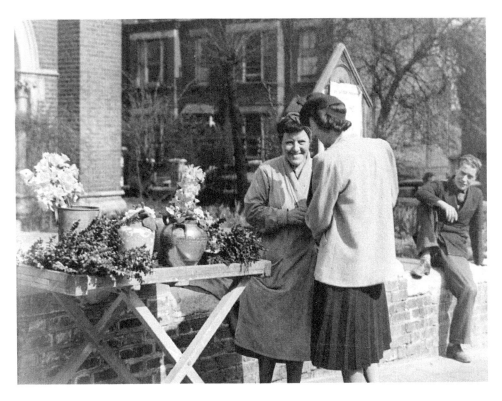

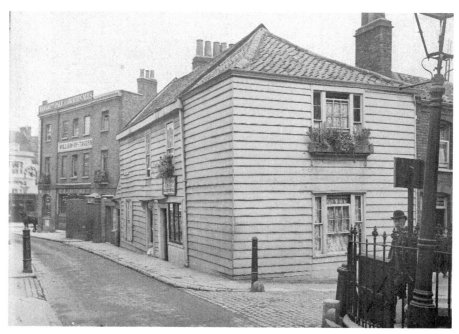

Looking east along Perrin's Lane towards the William IV pub in 1910. The timber-clad building was the dairy of William Summerfield but has now been replaced by housing with some weatherboarding.

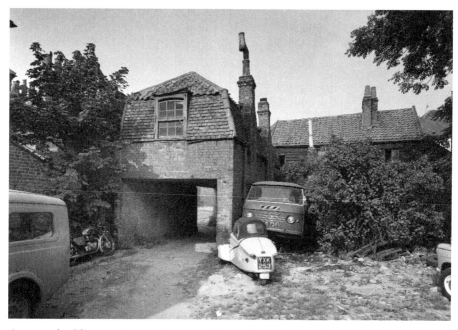

A mews building in Perrin's Lane in 1966. The photograph also shows the once-popular small Messerschmitt Bubbletop car parked outside. The building has since been demolished.

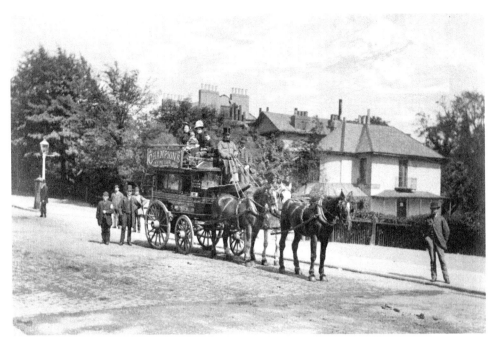

Knifeboard bus near the foot of Rosslyn Hill by Downshire Hill, 1887. The house with sixteen chimneys still survives on the south side of Pilgrims Lane but Elm Cottage, in the foreground, has disappeared.

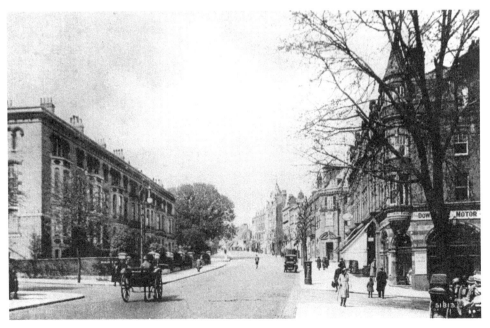

A similar view looking north from Downshire Hill in the 1920s. Downshire Motor Company at 28 Rosslyn Hill had cars available for hire, although horse-drawn traffic was still common.

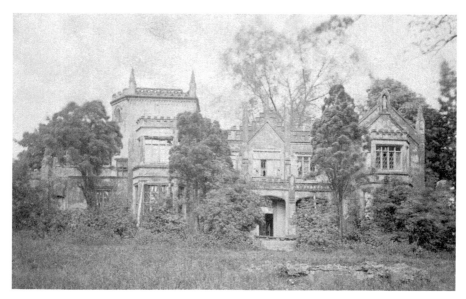

Frognal Priory, 1875. A retired auctioneer built this unusual pile, incorporating many architectural styles, and then filled the interior with a miscellaneous collection of objects and furniture. It was demolished about 1880 and Frognal Close occupies the site of the house. Lindfield Gardens crosses its former gardens.

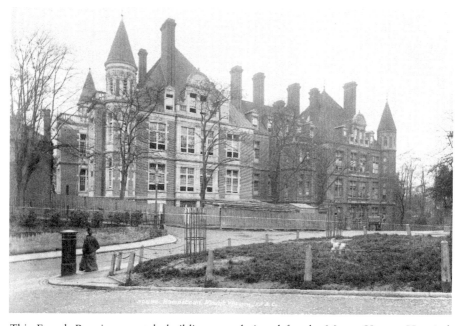

This French Renaissance-style building was designed for the Mount Vernon Hospital for Consumption and Diseases of the Chest by T. Roger Smith in 1880; later additions were made. In 1904 a new Mount Vernon Hospital was opened at Northwood and this site was closed and used for medical research. It is currently being converted into residential accommodation.

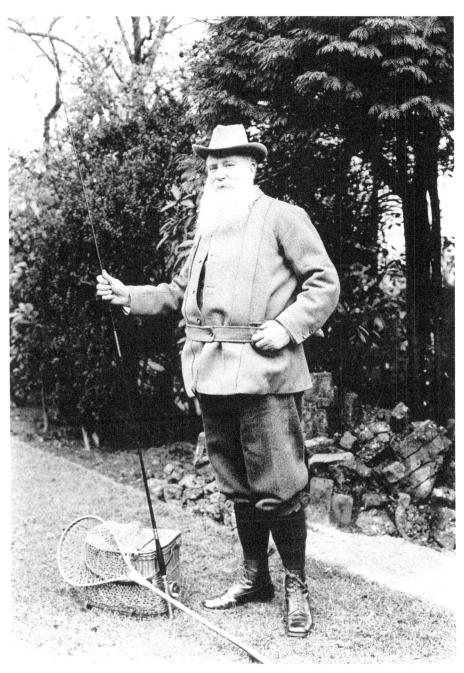

Thomas J. Barratt (1841–1914), Hampstead's great historian, whose thirty-year labour of love was his monumental work *Annals of Hampstead*, published in 1912. He was the chairman of the soap-making firm of A. and F. Pears from 1865 to 1914, and his imaginative advertising techniques made it a household name. The best-remembered publicity he devised was using Millais' painting of his grandson, with the addition of a bar of soap, as 'Bubbles'. He was also responsible for starting *Pears Cyclopaedia*, first published in 1897.

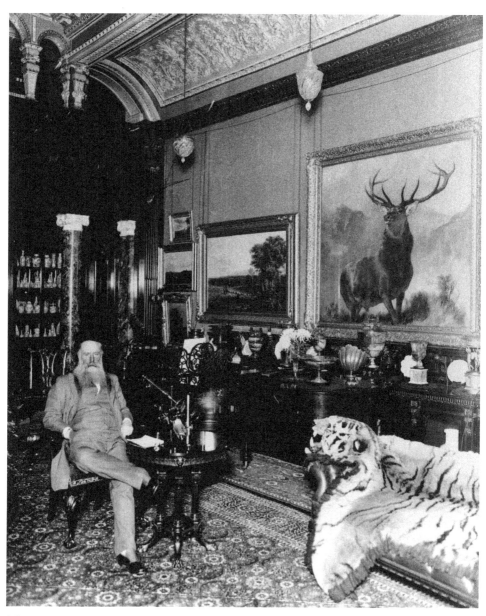

Thomas Barratt sitting in his Landseer library at Bellmoor, 1904. Barratt acquired a number of properties and built this palatial mansion opposite Whitestone Pond, living there from 1877 until his death in 1914. The Bellmoor flats now stand on the site of his house. This photograph and those on the following two pages give a fascinating insight into his style of life. On the wall in the library is the famous painting of *The Monarch of the Glen* by Sir Edwin Landseer. Barratt was a keen art collector and owned many of Constable's Hampstead pictures. In 1916, two years after his death, Christies had a two-day sale of his drawings, pictures and statues, which fetched £28,487. *The Monarch of the Glen* sold for 5,000 guineas (£5,250).

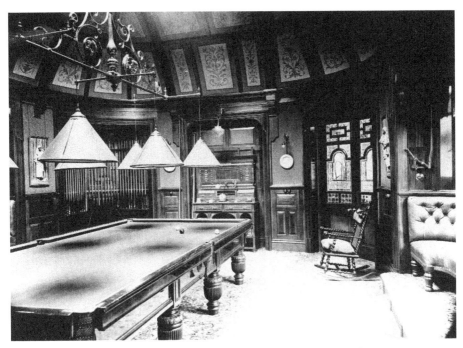

The billiards room, Bellmoor. Other spectacular rooms included a fish conservatory, a Moorish room, Adam drawing room, map room and a butterfly room.

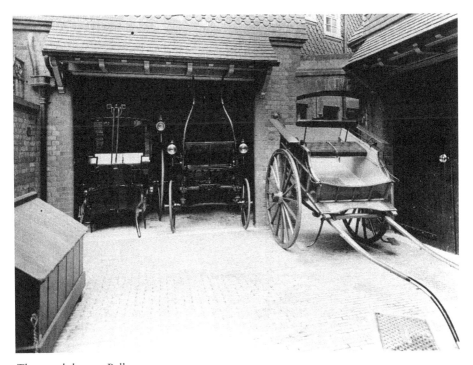

The coach house, Bellmoor.

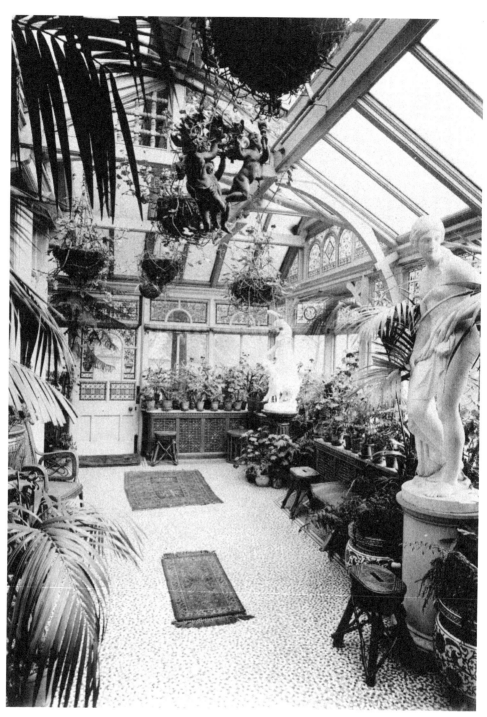

The conservatory, Bellmoor, with marble sculptures *The Bather* and *Esmeralda and the Goat*.

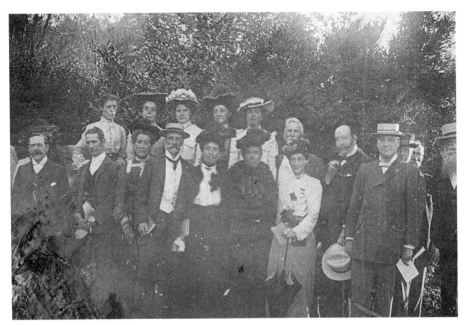

A souvenir photograph of the Hampstead Antiquarian and Historical Society's trip to Winchester on Saturday 11 July 1903. The society was established in December 1897 with Sir Walter Besant as its first president.

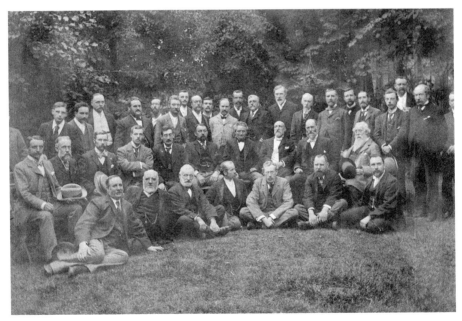

Members and officers of Hampstead vestry after beating the bounds of the parish, 30 July 1896. This eight-hour walk involved following the exact boundaries and inspecting boundary stones and marks, even if that meant crossing railway lines, scaling walls and fences, going through houses or trampling through flower beds!

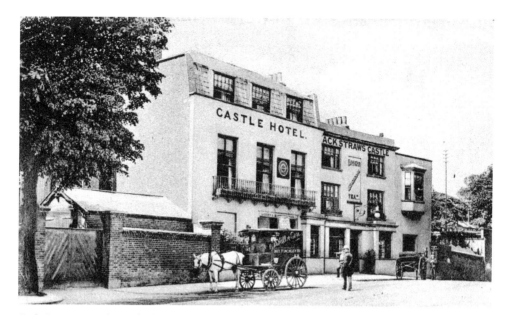

Jack Straw's Castle, with the van of William Hill and Son, bakers, outside, *c*. 1906. This was the highest pub in London, with excellent views from some of the rooms. It was named after a leader of the Peasants' Revolt of 1381, for which there is no evidence of any local connection; the name was first used centuries later. It was bombed during the Second World War and rebuilt in 1962 in a totally different style, with a castellated and weatherboarded front. Now converted into flats and a personal training club.

The Spaniards Inn, showing the once familiar scene of donkey riders, *c*. 1906. Donkeys could be hired by the hour, day or for short rides. The pub dates from the eighteenth century, and across the road is an eighteenth-century toll house, the restoration of which received a Civic Trust award.

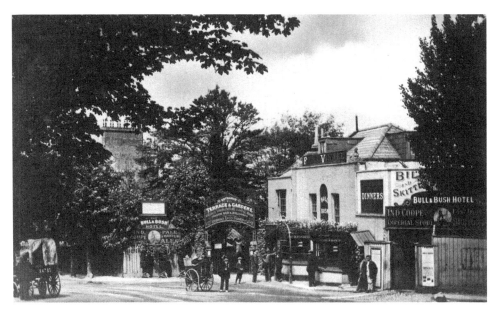

The Bull and Bush, *c.* 1906. The pub was immortalized in Florrie Forde's song 'Down at the Old Bull and Bush'. It was mentioned as a pub as early as 1721, although it was originally a farmhouse. William Hogarth lived here and laid out the gardens which became a popular feature. The present building dates largely from 1924 and has been rebuilt extensively since.

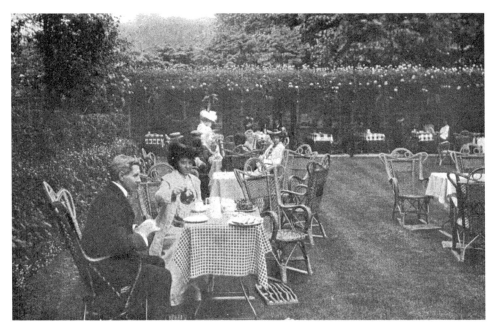

The lawn at the Bull and Bush, *c.* 1905. Pubs like the Bull and Bush made a popular feature of their tea-gardens to attract the visitors to Hampstead Heath and the fairs. Music became a feature too, especially for a Cockney 'knees-up'.

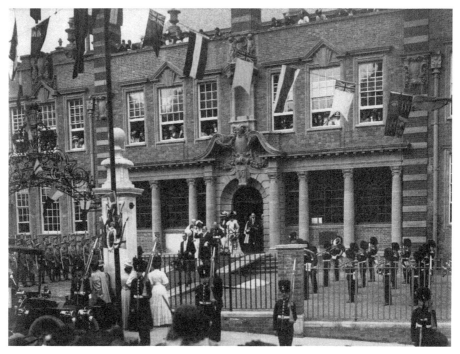

The opening of University College School, Frognal, by His Majesty King Edward VII, 26 July 1907. The school was designed by Arnold Mitchell. The original building was in Gower Street, Bloomsbury, where the school was founded in 1830.

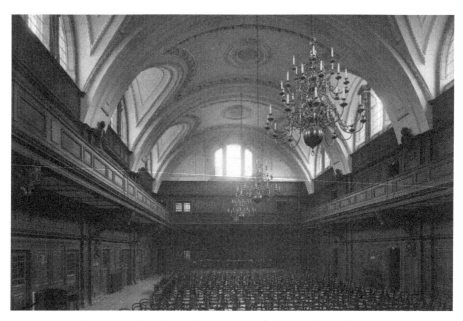

University College School hall was damaged by fire in 1978 and this was one of the photographs used to provide the detail necessary to assist its restoration.

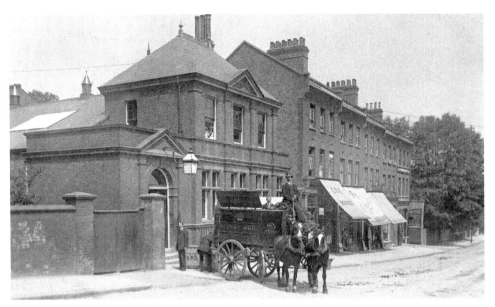

Downshire Hill postal sorting office was opened in 1891. At that time local pillar boxes would be emptied as often as thirteen times a day, with local letters being delivered only a few hours after they had been posted. The building has been used since as a Social Security office, puppet theatre and now a doctors' surgery.

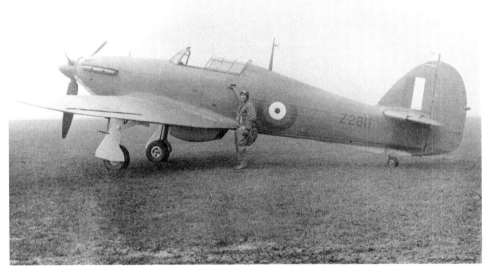

The Hampstead Hurricane Fund was set up in 1940 to collect funds to provide a flight of three aircraft from the people of Hampstead. One of the Hurricanes is pictured here. As part of the appeal, a Messerschmitt 109, which had been shot down but was virtually unharmed, was placed on display on the Paddock on Hampstead Heath, just off North End Way.

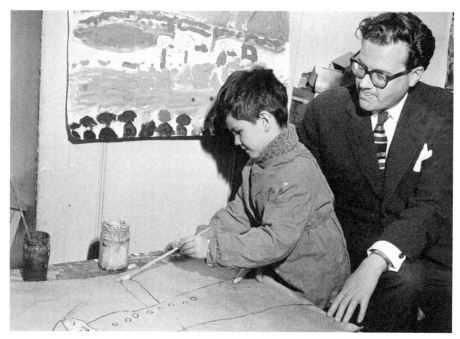

Jeremy Mortimer, aged five, tries his hand at a painting at the Rhoda Pepys Art Centre for the Hampstead Festival of Music and Arts Children's Painting Competition, 1961. He is watched by his father, John Mortimer, the barrister, playwright and author, who was born in Hampstead and was then living at 23 Harben Road, Swiss Cottage.

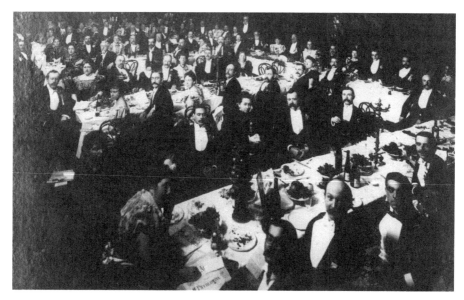

The complimentary dinner of the Vestry of St John, Hampstead, to Sir Henry Harben, KT, chairman of the vestry, at the Throne Room, Holborn Restaurant, 28 October 1897. Sir Henry Harben was chairman of the Prudential Assurance Company, a Hampstead vestryman from 1874 to 1900 and Hampstead's first mayor.

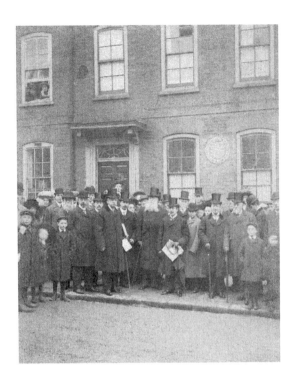

Right: A plaque to Thomas Park, antiquary, and his son John James Park was unveiled at 18 Church Row on 1 January 1910 (although the plaque says 1909!) by Henry Wheatley, President of the Hampstead Antiquarian Society. John James Park published his first history of Hampstead in 1814, aged nineteen.

Below: The Guardians of the Poor of St John, Hampstead, 1930. They had been responsible for poor relief, including admissions to New End Hospital, until their responsibilities were transferred to the London County Council in 1930. The matron of the hospital is on the left.

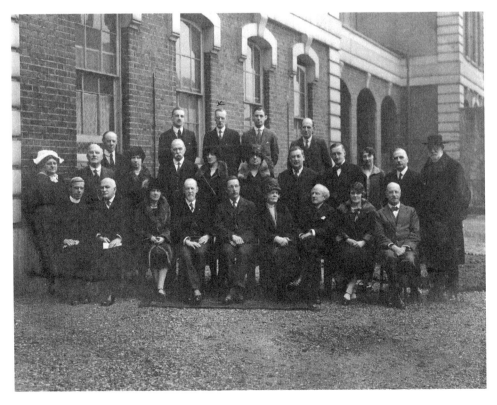

Lower Heath Cottages in Willow Road, *c.* 1906. These eighteenth-century cottages were replaced in 1938 by 1–3 Willow Road, designed by Ernö Goldfinger (a leading architect of the Modern movement), who lived at no. 2. His house was transferred to the National Trust in 1994 and is open to the public.

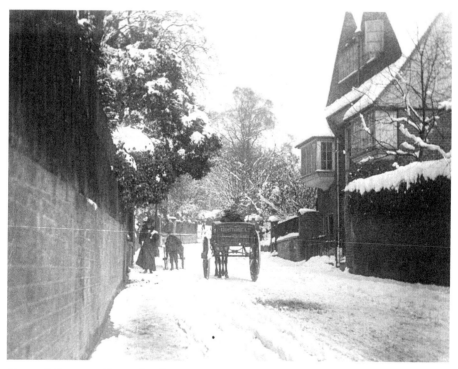

Frognal Cottage, Frognal, after snow, 3 March 1909. This is now numbered as 102 Frognal. A cart from Lidstone Ltd is delivering from their butcher's shop at 17 Hampstead High Street.

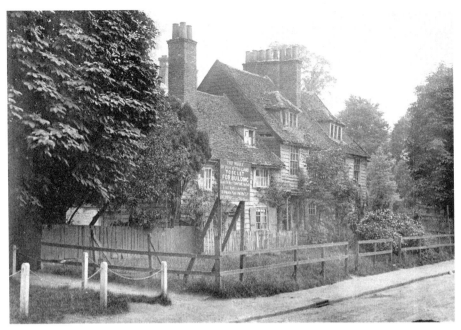

One of the most popular views of North End in old postcards was Hope Cottage, where the painter John Linnell lived in 1822 and where William Blake stayed. The site is now covered by 6–12 North End. This photograph dates from about 1910.

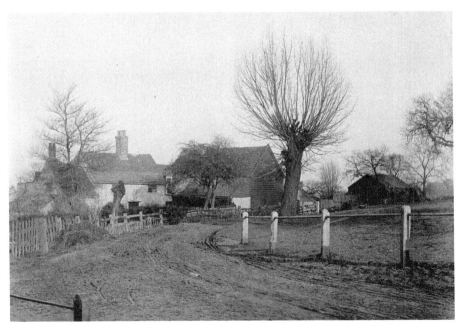

Prior to the building of Hampstead Way, this track to the south was the route to Wyldes Farm. The two buildings are now Old Wyldes and Wyldes, the farmhouse and barn of a former 340 acre estate owned by Eton College. The photograph was taken in about 1887.

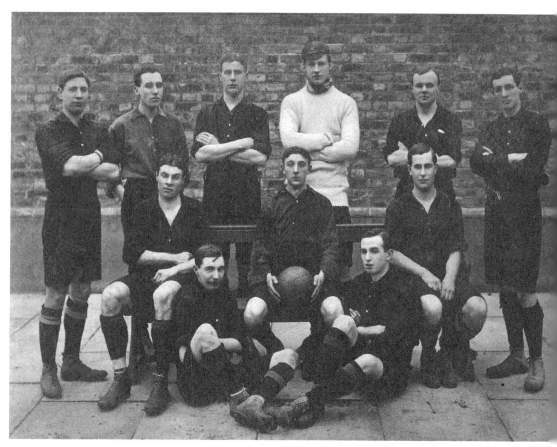

Hampstead Football Club, 1903–4. Back row, left to right: H.W. Gregory, H.E. Franck, W.H. Petty, F.G. Agonily, W. Tassell, W.M. Smith. Middle row: A.H. Marshall, H.E. Dale, A.G. Wallas. Front row: R.F. Bailey, C. Chapman.

SECTION TWO

HAMPSTEAD HEATH

*Viewing London from Parliament Hill, 1939. From this point the
land drops sharply to the south, thus providing an excellent vantage
point to view London's ever-changing landscape. In recent years the
additional name of Kite Hill has been used for it, influenced by the
traditional pursuit of flying kites here.*

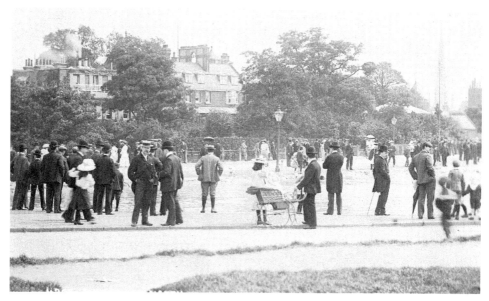

Whitestone Pond, looking east towards Bellmoor, *c.* 1904. It acquired its name from a white milestone nearby that recorded a distance of 4½ miles to Holborn Bars. Ramps enabled horses to enter the pond for refreshment. It has also been a popular venue for paddling, model-boat sailing and skating in winter.

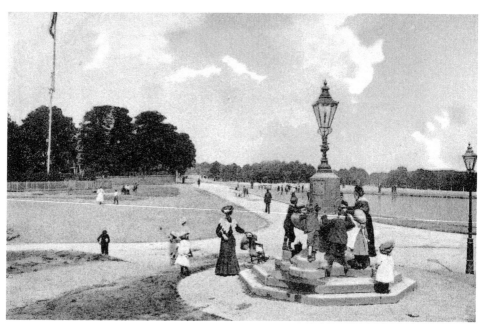

The fountain by Whitestone Pond, *c.* 1905. It was erected by the Metropolitan Drinking Fountain and Cattle Trough Association in May 1893. It cost £280 and was the gift of J. Wills. The spot became a local Speakers' Corner and the scene of fights between fascist speakers and members of the public in the 1930s.

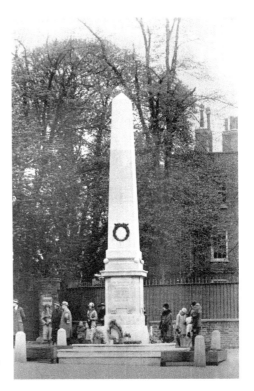

Right: The Hampstead war memorial, dating from 1922, was moved in 1953 from the middle of the road to this site outside Heath House. At that time it was extended to include the dead of the Second World War. Field Marshall Viscount Alanbrooke unveiled the panels and the Bishop of London performed the dedication.

Below: An emergency water supply replaced the old Whitestone horse pond during the Second World War. A number of these reservoirs were built in strategic positions in order to supply water to put out fires when the mains supply had been damaged by bombing.

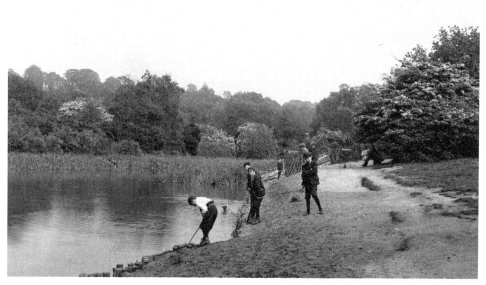

The Leg of Mutton Pond on the West Heath, *c.* 1905. The name resulted from its shape, and it is claimed that it was dug by paupers receiving parish relief in the early nineteenth century.

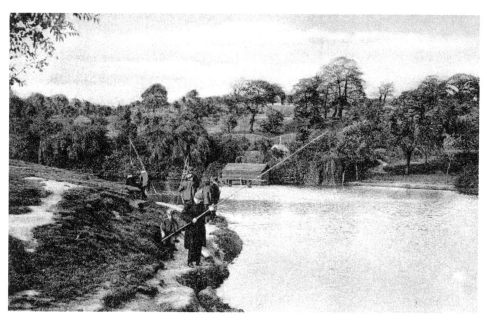

The bathing pond on Hampstead Heath, *c.* 1906. The ponds on the heath are used for a variety of purposes, including swimming, fishing, model boats and as a bird sanctuary.

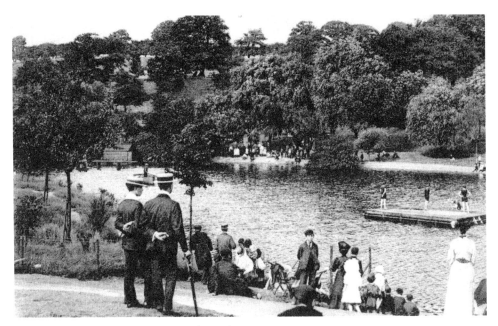

Watching the bathing on Hampstead Heath, *c.* 1905.

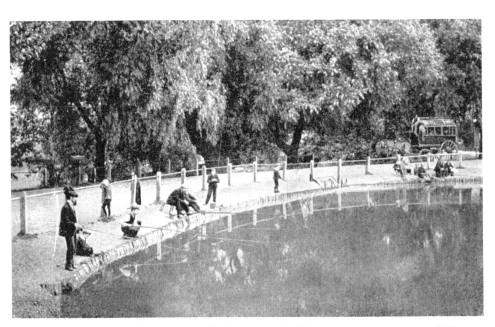

Fishers hoping for a catch at the Leg of Mutton Pond, 1906. In recent years a mesolithic site (*c.* 7,000 BC) to the east of the pond was discovered and excavated.

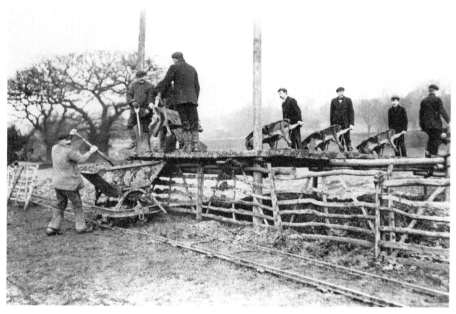

Removing mud from a pond on Hampstead Heath, *c.* 1900. The photograph was taken during a visit of the Central Unemployment Committee to their various works in North London.

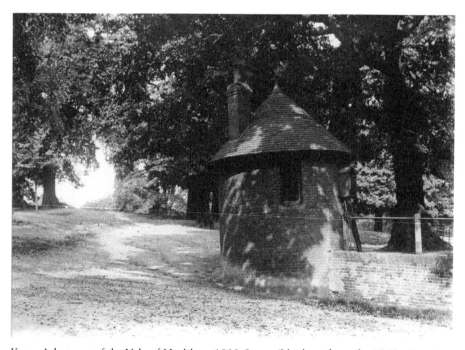

Keeper's hut east of the Vale of Health, *c.* 1900. It possibly dates from the 1840s. Running south from it can be seen part of a ha-ha, a sunken wall used to provide an unspoiled vista in one direction while at the same time containing sheep and other animals.

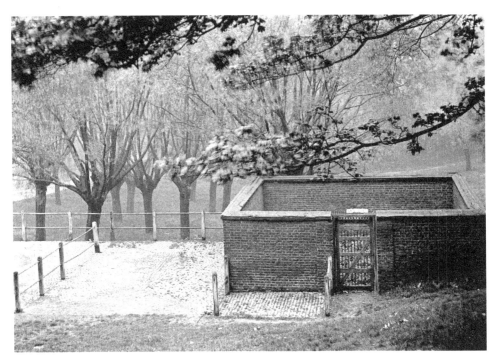

The pound below Spaniards Road, *c.* 1890s. It dates from 1787 and was used to impound stray animals on Hampstead Heath. Behind it was part of the lord of the manor's unpopular tree planting on the open heath in the 1860s.

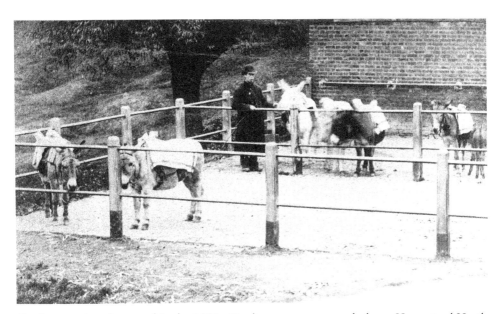

Donkey stand at the pound in the 1890s. Donkeys were seen regularly on Hampstead Heath until about 1992. Impromptu donkey races on the heath and nearby roads caused endless inconvenience and complaints.

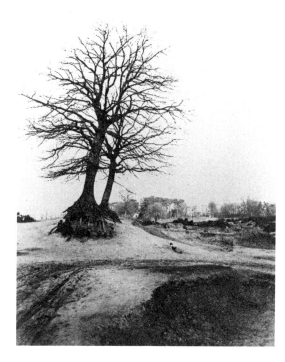

Left: This photograph shows the results of sand and gravel extraction from Hampstead Heath, 1866. Surprisingly, the two oaks, seen here and below, still survive on Sandy Heath, north of Spaniards Road near Spaniards End. However, they are joined together by a metal collar for support.

Below: Sir Thomas Maryon Wilson, lord of the manor, considered that if he was frustrated in his plan to build on parts of Hampstead Heath he would seek the most profitable way of exploiting the land. In particular, he sold the rights to extract huge quantities of sand and gravel around Spaniards Road. (See also the Introduction.)

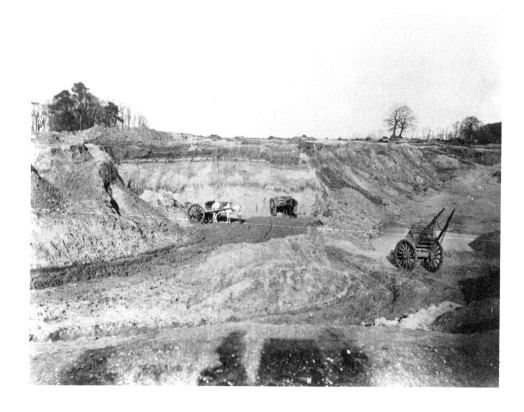

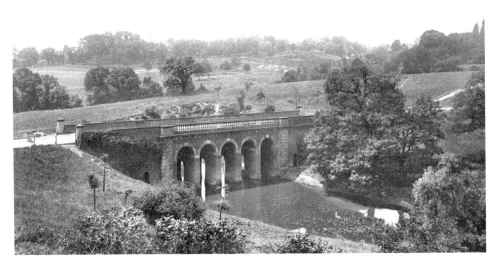

The viaduct, Hampstead Heath, *c.* 1890s. This was started in 1845 by the lord of the manor as part of his proposed development of East Park, now part of Hampstead Heath. The viaduct was to carry the road to his villas across a swampy valley, later drained to form the viaduct pond, an ornamental lake.

Hampstead from the viaduct, Hampstead Heath, 1890s.

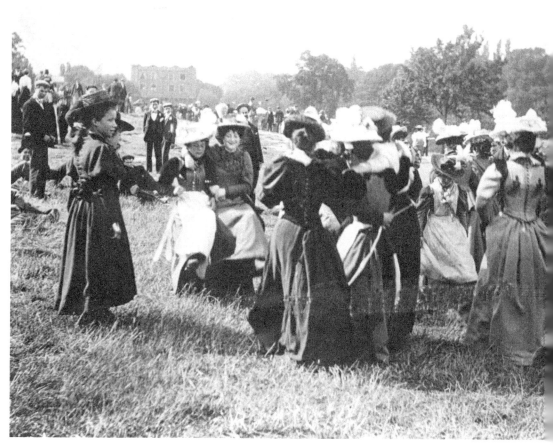

Cockney 'knees-up' on Hampstead Heath, *c.* 1905. The Vale of Health Hotel is in the background.

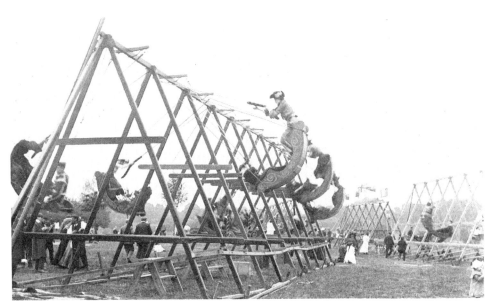

A postcard of swing boats at Hampstead Fair, *c.* 1916. Sets of swing boats had appeared at the fairs by Easter 1882 and had been installed at the permanent fair next to the Vale of Health Hotel by 1886.

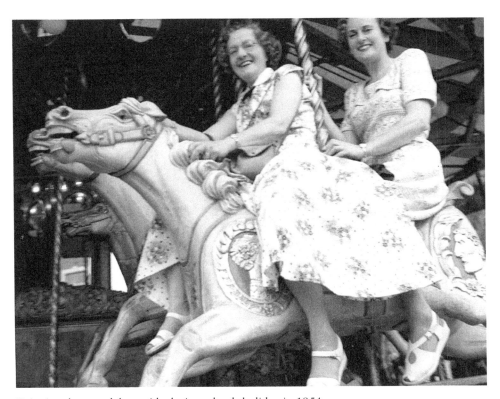

Enjoying the roundabout ride during a bank-holiday in 1954.

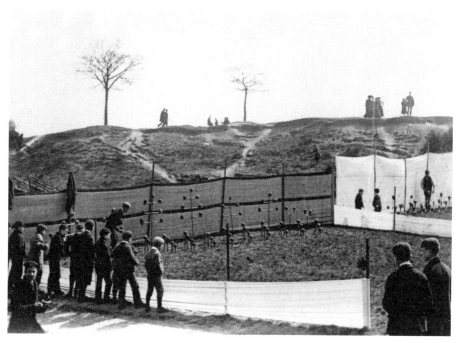

A coconut shy at Hampstead Heath near the Vale of Health, *c*. 1900.

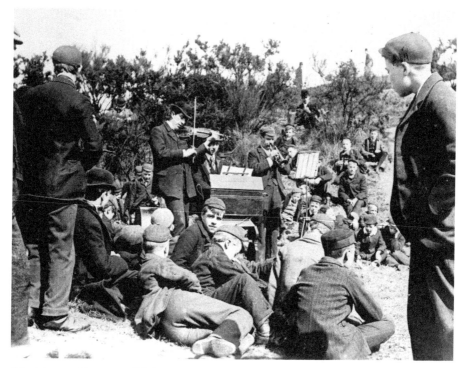

Musicians at Hampstead Fair, *c*. 1900.

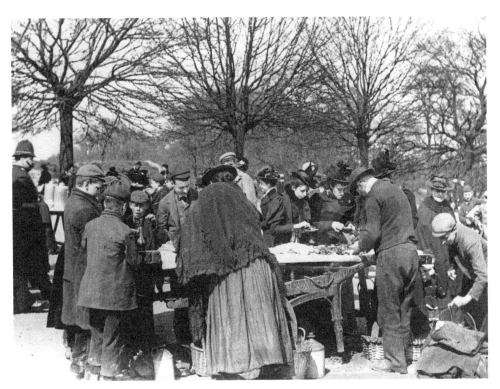

A whelk and cockle stall of E. Forster of Islington at Hampstead Fair, *c.* 1900.

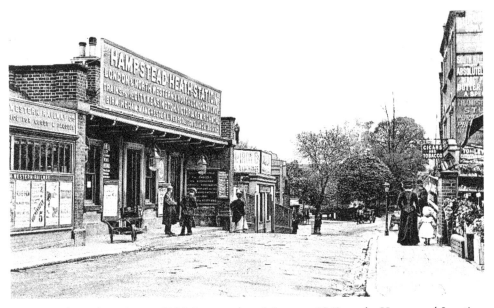

Hampstead Heath station, *c.* 1905. It opened on 1 January 1860 on the Hampstead Junction Railway and was heavily used by the hordes of East Enders visiting the heath and the fair. This entrance was replaced by a new building in 1968.

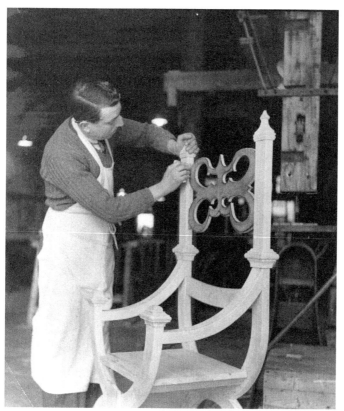

Above: Looking from near Spaniards Road to the Vale of Health in 1870. Dominating the scene is the Vale of Health Tavern in the background, now the site of Spencer House. The prominent building in the centre is Villas on the Heath. On the extreme left scaffolding poles indicate that a building is under construction, possibly a tea-room.

Left: Making a period chair stage prop in the workshops of the Old Vic in the Vale of Health, 1950s. The Athenaeum, a former chapel-like building, was used by the Old Vic and Sadler's Wells theatres.

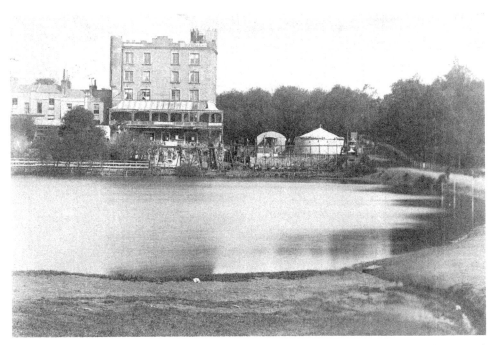

Vale of Health Tavern, *c.* 1890s. This large building was erected by the Suburban Hotel Company as a tavern, hotel and tea-gardens to cater for the large numbers of visitors to Hampstead Heath and was able to seat 2,000. However, it did not prove to be a great success for the owners.

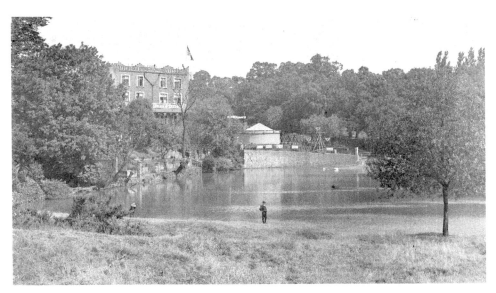

Vale of Health Hotel, *c.* 1907. The pub was rebuilt in 1904–5 and renamed as a hotel rather than a tavern. The upper floors were rented out as studios and Stanley Spencer painted here from 1922 to 1927. It closed in 1960, was demolished in 1964 and Spencer House erected on the site. The part of the Vale of Health Fair on the banks of the pond closed down in the mid 1980s.

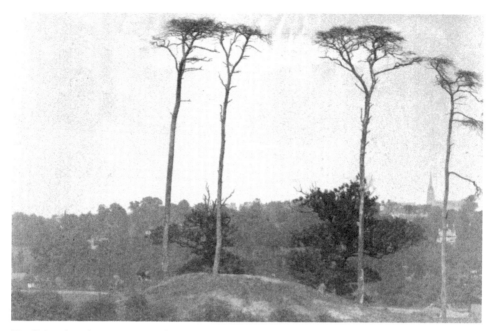

Tradition has long associated the mound in this 1890s picture with the burial place of Boudicca. Excavations in 1894 revealed no trace of a burial and showed that much of the earth was a recent addition. It was possibly no more than a Kenwood estate landscaping feature with planted Scots pines.

The firs on Sandy Heath, 1890s. The trees had been planted by an earlier occupant of The Firs in Spaniards End, the house behind the holly hedge in the background. Constable was one of the many artists who painted this group of trees, most of which have now gone.

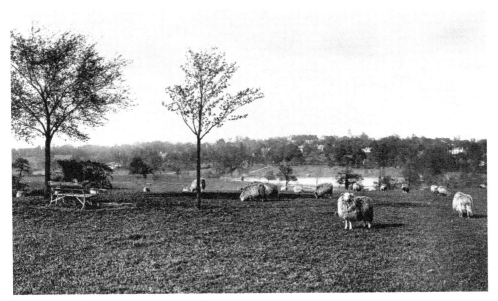

Sheep on Hampstead Heath, *c.* 1913. Sheep were still grazed here until *c.* 1952. One of the shepherds, George Donald, lived in a hut for ten months of the year. His flock varied from 200 to 1,000 sheep. He looked after them for 'a farmer out Finchley way' who fattened them for the London market.

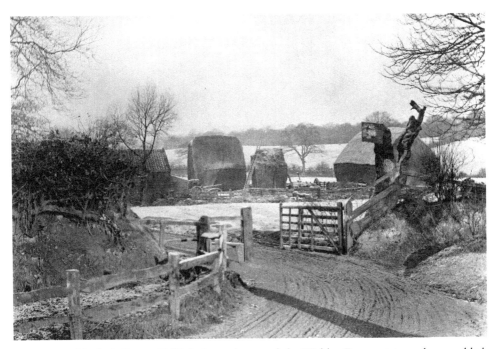

Entrance to Tooley's Farm, 1887. It formed part of the Wyldes Farm estate and was added to Hampstead Heath in 1907. The surrounding land was developed as Hampstead Garden Suburb. The farm track can still be identified as a path on the north side of Wildwood Road.

Left: North End Avenue, *c.* 1904. Some historians have suggested that was the road into Hampstead from Finchley and the north before the cutting for North End Way was made. Much of it is now a footpath and many of the trees have been lost.

Below: Looking down East Heath Road, *c.* 1900. Up to the late eighteenth century the road had been merely a farm track. As Hampstead village expanded eastwards across heath land this was built as a new carriage road to make access easier and to avoid the steep parts of the town centre.

Looking north from the Bull and Bush towards Jack Straw's Castle, *c.* 1906. The construction of North End Way from Hampstead to Hendon dates from the 1730s.

The donkey man stands at the top of North End Way with animals for hire, 1887. The view was taken looking south by the wall of The Hill, now called Inverforth House.

Judges Walk, *c.* 1890s. From this spot can be seen the hollow where Branch Hill Pond was once situated and views towards Harrow. It was a favourite vantage point for Constable's paintings.

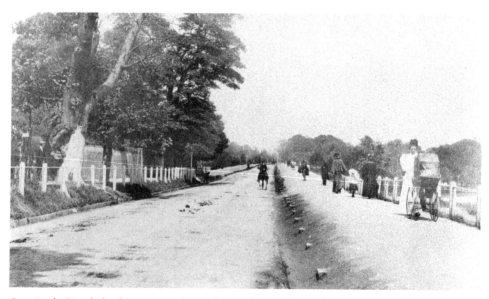

Spaniards Road, looking towards Highgate, late 1890s. The extensive sand and gravel extraction on either side of the road has meant that it runs on top of a clearly defined ridge across the heath. It was a toll road, established in 1717 and paved with gravel from the heath.

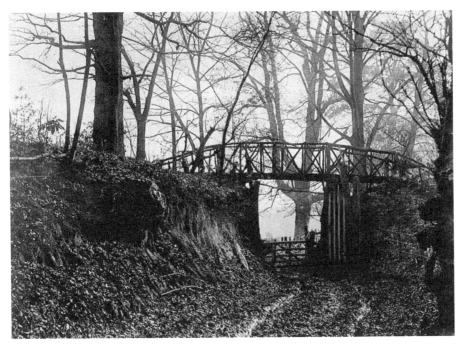

William Lever (later Lord Leverhulme) made his fortune with Sunlight soap and purchased The Hill, North End Way, together with two adjacent properties. He rebuilt the house, now called Inverforth House, but was unable to extinguish the right of way which divided his land and it had to be bridged by this rustic bridge, shown here about 1906.

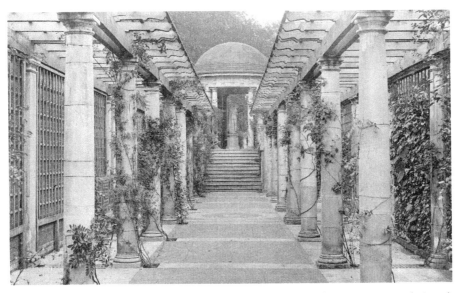

The pergola, Hill Gardens, 1920s. Between 1906 and 1925 Thomas Mawson designed an 800 ft long pergola, over 15 ft above the level of the surrounding heath, and replaced the rustic bridge in the top picture. After extensive renovation it was reopened to the public on 31 May 1995 by the Lord Mayor of the City of London.

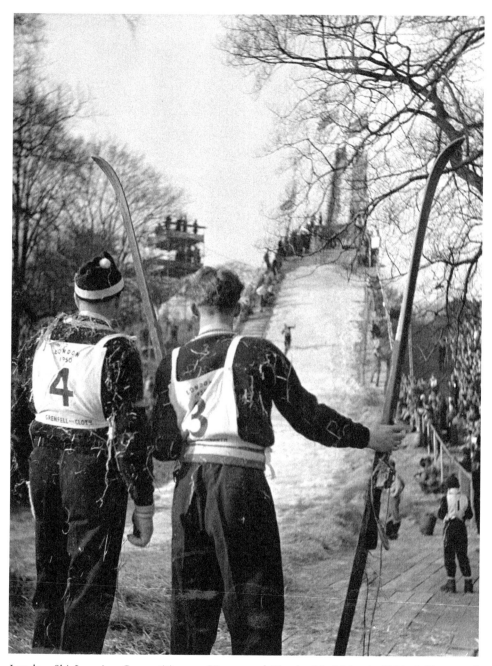

London Ski Jumping Competition on Hampstead Heath, 24–5 March 1950. Still covered with straw from the end of their run, two skiers watch the next man on his way down. Forty-five tons of snow from Norway had to be unpacked from boxes and laid on the ski jump erected on the open slopes near the Vale of Health. Twenty-five acres of the heath had to be fenced off for jumping and spectators.

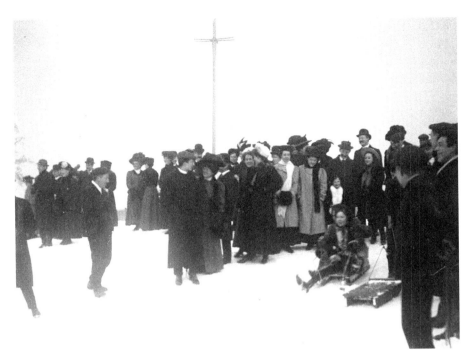

Tobogganing at Whitestone Pond, 5 March 1909.

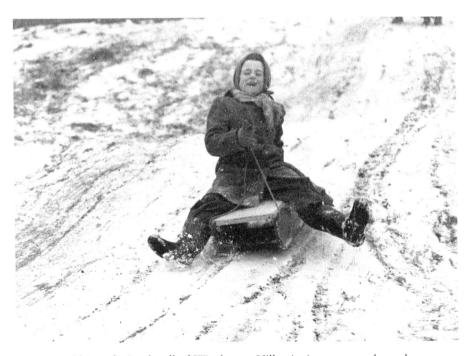

Five-year-old Pamela Southwell of Winchmore Hill enjoying a run on her toboggan on
Hampstead Heath on 18 February 1956.

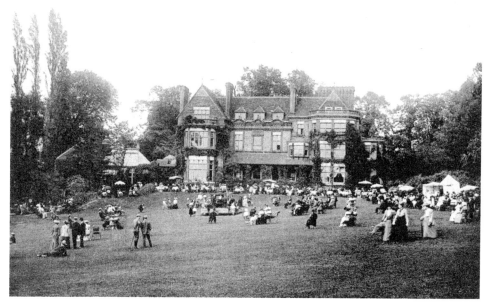

The Mansion, Golders Hill Park, *c.* 1905. Thomas Barratt acquired the mansion and 36 acres for £38,000 at auction in 1898 to prevent the site being redeveloped. A successful public subscription fund raised the money to refund him and make it an open space available to the public. The house was demolished following bomb damage during the Second World War.

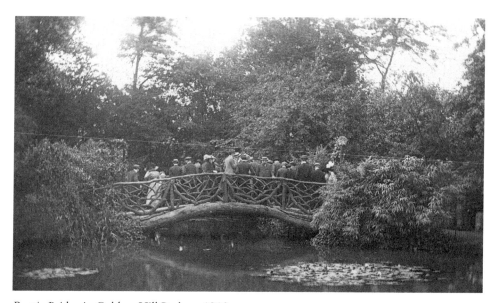

Rustic Bridge in Golders Hill Park, *c.* 1913.

SECTION THREE

WEST HAMPSTEAD
& KILBURN

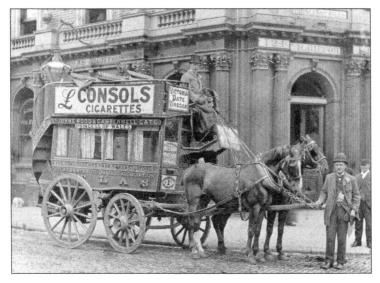

*Omnibus outside the Princess of Wales pub on the corner of Abbey
Road and Belsize Road. The landlord's name above the door, Thomas R.
Gifford, dates the picture between 1897 and 1901. The pub was rebuilt
and renamed the Lillie Langtry and is currently called The Cricketers.*

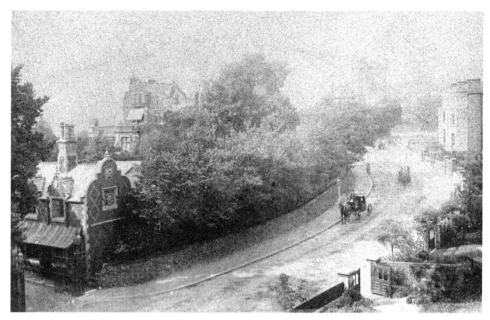

West End Lane, 1880. The view, taken from near Woodchurch Road, shows the Oaklands Hall estate. The last occupant of the house was Sir Charles Murray, traveller, linguist and writer, whose achievements included shipping the first hippopotamus to London in 1850. The house was pulled down in October 1882 and the estate is now covered by the block of Kingsgate Road, Gascony Avenue, West End Lane and Hemstall Road.

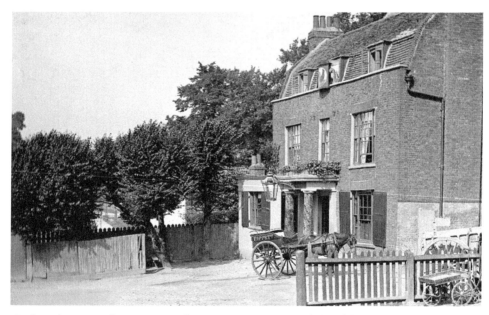

Cock and Hoop pub on West End Lane, c. 1890s. One of the older buildings of West End Village, established by 1720, it was closed in 1896 following irregularities concerning its licence and Alexandra Mansions was built on the site in 1902.

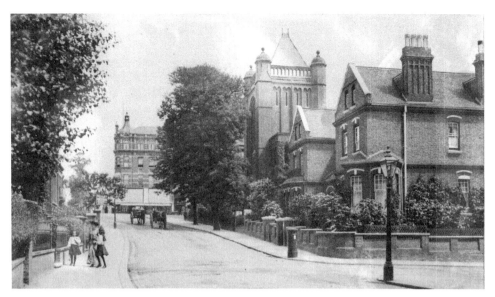

Dennington Park Road looking towards West End Lane, *c.* 1904–13. The Hampstead Synagogue is on the right. It was designed by Delissa Joseph to hold 700 worshippers and was finished in 1892 at a cost of £11,000.

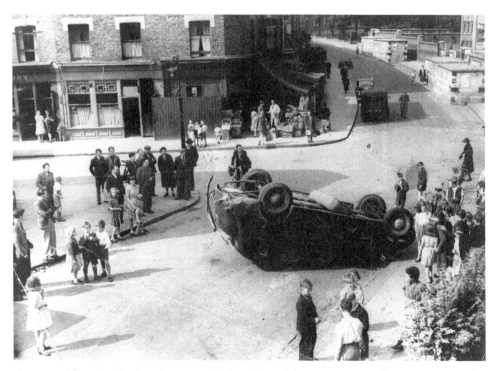

A car accident in Messina Avenue at its junction with Kingsgate Road, *c.* 1942–3. In the distance can be seen two wartime street shelters outside Kingsgate School. On the corner is Hovel's greengrocer's shop, at 92 Kingsgate Road, now a restaurant.

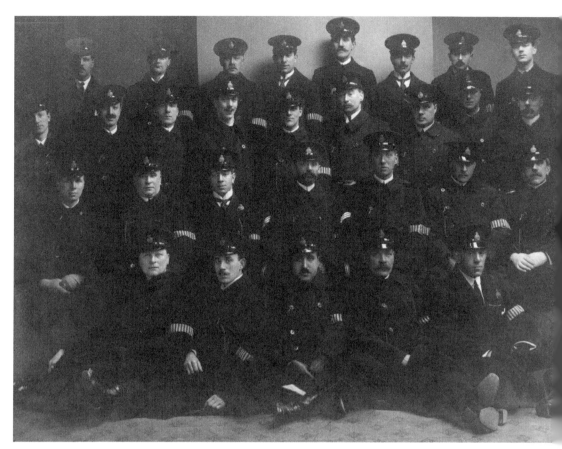

Special Constables 'S' Division, West Hampstead 2 a.m. to 6 a.m. squad. When this undated picture was taken the police station was situated at 90 West End Lane.

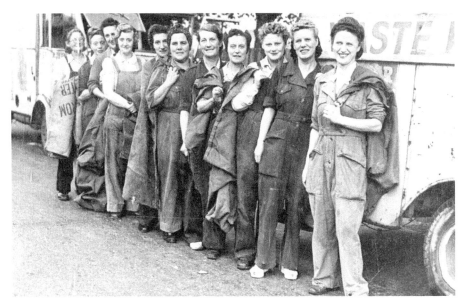

Salvage girls during the Second World War. From 1939 to 1945 women increasingly took over work that had previously been the province of men. The women operated out of the council depot in Lymington Road.

Emmanuel Primary School teaching staff, possibly 1928. Back row, left to right: Miss Berry, Miss Stanyon, Revd C.N. de Vine, Miss Sinclair. Front row: Miss Page, Miss Lavender (headmistress), Miss Austen. The school opened in 1845 but consisted then only of one classroom and a cottage for the schoolmistress.

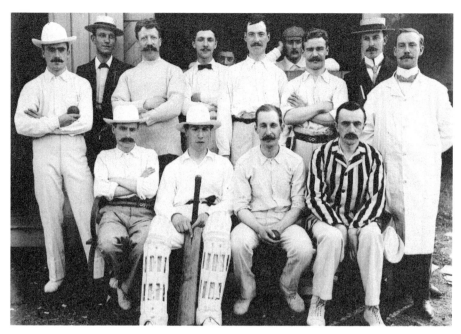

Hampstead Cricket Club, undated. The club moved from a ground off Belsize Road, near St Mary's Church, to Lymington Road in 1877. In 1924 it purchased its ground for £25,000 to prevent the ground being developed.

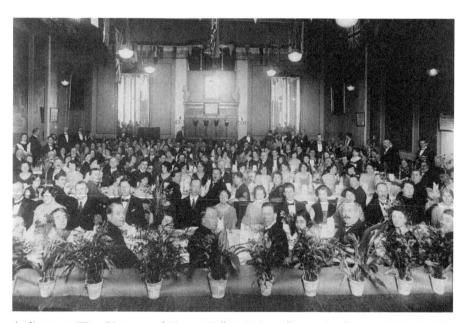

A dinner at West Hampstead Town Hall, 165 Broadhurst Gardens, c. 1921–2. The building was built as a factory in 1884 but was later used mainly as a private place of entertainment. Despite its name it never was a municipal building. It is currently occupied by the English National Opera.

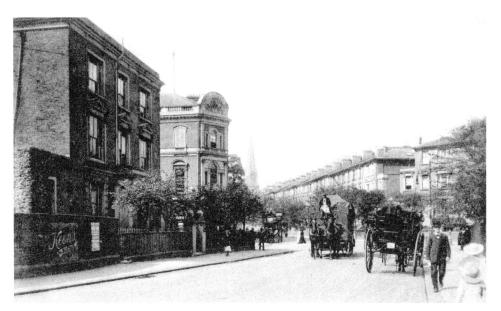

Abbey Road, looking north at the junction of Belsize Road, *c.* 1904. A multi-storey car park is now on the left side of the road. A pub named after the Princess of Wales, the wife of the future Edward VII, has been rebuilt under Emminster flats. It was renamed after her rival Lillie Langtry, who was Edward's mistress, and is currently called The Cricketers. Opposite the pub are the high-rise flats Snowman and Casterbridge.

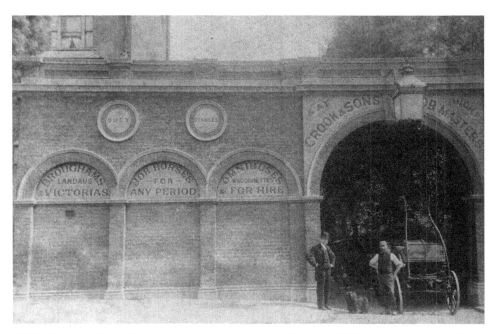

C.W. Crook and Sons, jobmaster, Quex Mews, Quex Road, *c.* 1890s. He hired out carriages by the hour, the day or even as long as a year. Newly built town houses are in the Mews now and the lettering only disappeared in the 1990s.

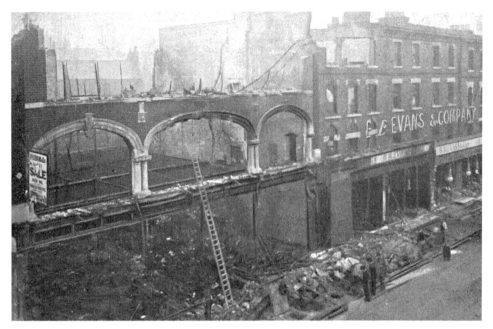

Fire at B.B. Evans department store, 13 January 1910. The store was designed in 1905 by G.A. Sexton, incorporating modern facilities his client had seen at more prestigious West End stores. In 1962 it still employed five hundred people but it closed down in 1971. The attractive building still survives as 142–62 Kilburn High Road but is currently empty, with a big retail development planned for it.

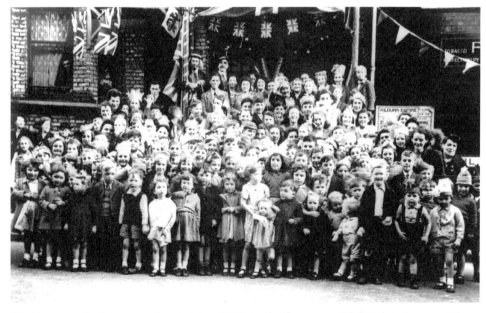

VE Day party in Maygrove Road, May 1945. In the front row Edith White is second from the left, and the tall boy third from the right is Harold Arnold.

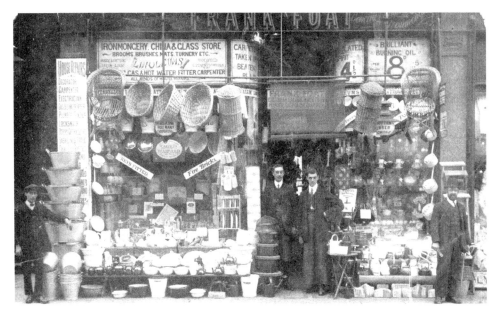

No. 273 West End Lane, *c.* 1915. Sidney Venning joined the ironmongery trade in 1899, aged fourteen. In 1915 he took over this shop and ran it for sixty years. He died in 1982 aged ninety-seven.

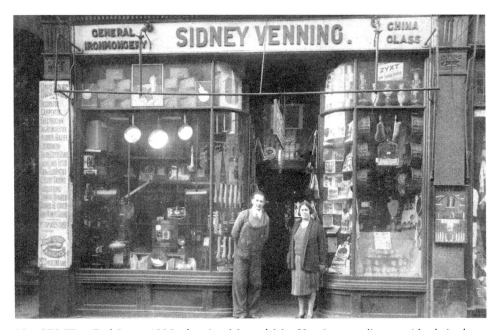

No. 273 West End Lane, 1935, showing Mr and Mrs Venning standing outside their shop. When he first started the business the customers were nearly all housekeepers and other servants and he rarely saw the purchasers. His son, also Sidney, followed him into the trade, finally retiring and closing the business on 23 August 1986, aged sixty-nine. The building is now used by La Broccha restaurant.

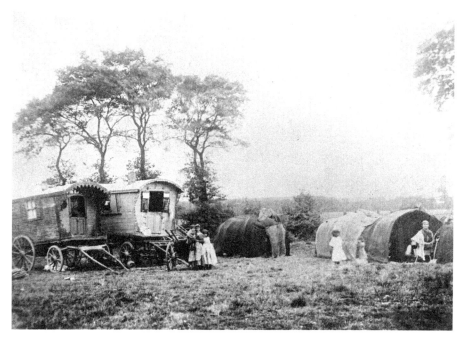

Gypsies on Fortune Green. The green was once considerably larger than it is today and had been part of the manorial 'waste' of the Manor of Hampstead, but there were rights for certain copyholders to let their animals graze on it, cut turf, etc. Gypsies visited the green up to the 1890s.

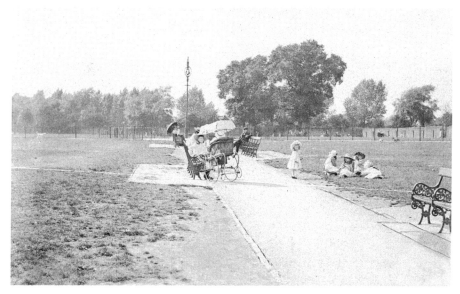

Fortune Green, 1905. In the nineteenth century the lord of the manor enclosed part of the land. In 1875 Hampstead Vestry acquired part for Hampstead Cemetery. Further attempts were made to redevelop it in the 1880s and 1890s, defeated only by strong local protest. It was purchased by the vestry and laid out for public uses in 1898.

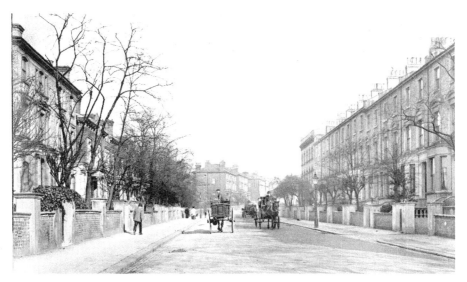

Alexandra Road, undated. This was swept away in 1972 and replaced by Camden Council's Alexandra Road Estate to house 1,660 people in 520 homes. It was given listed building status in 1993, one of the most modern buildings to be so recognized. A small stretch of Alexandra Road still remains east of Loudoun Road.

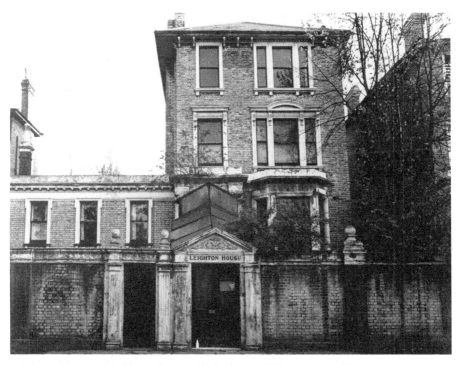

Leighton House, 103 Alexandra Road, the home of the actress Lillie Langtry, *c.* 1960s. She became the mistress of the Prince of Wales, later King Edward VII, who regularly visited her here. The house was demolished in about 1971.

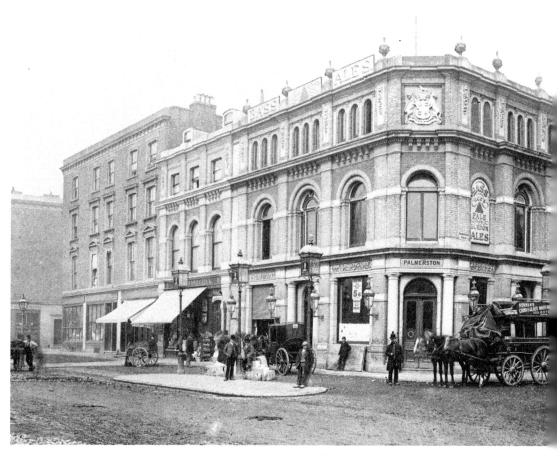

The Palmerston Hotel, later the Lord Palmerston, Kilburn High Road, *c.* 1870. It was built in 1860 and after a closure for rebuilding in 1977 it reopened as The Roman Way, a reminder of the old Roman Watling Street which passes the door. An extra storey has been added since this photograph was taken, together with an extension to the front of the building. Now a Nando's Restaurant.

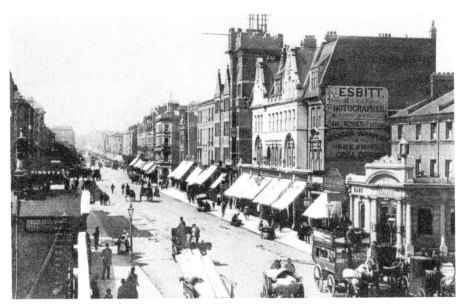

Kilburn High Road, looking north from Belsize Road, *c.* 1889–97. The bank on the right was rebuilt by 1898 and has a plaque on it commemorating Kilburn Wells, which once stood on the site. Now a Holland & Barrett health food shop.

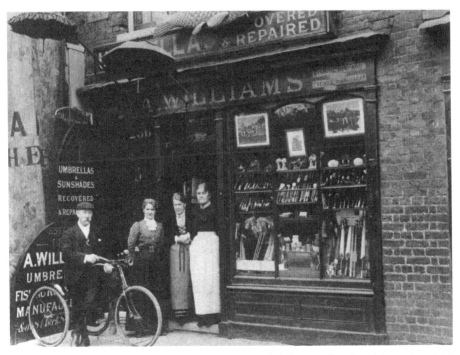

Albert Williams, umbrella maker and repairer, and fishing rod and tackle maker, 256 Kilburn High Road, *c.* 1896. Note the superb shop signs of fish and open umbrellas. The building has been rebuilt and is now a closed internet café.

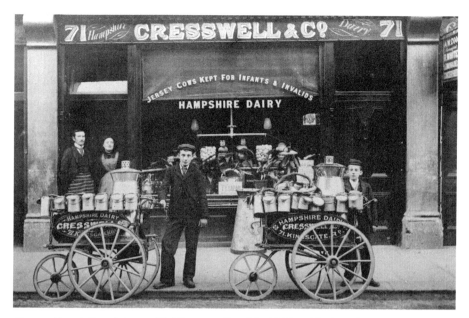

Cresswell and Co., dairy, at 71 Kingsgate Road in 1893, with the advertisement 'Jersey cows kept for infants & invalids'. These cows provided creamy milk. The hand cart with milk churns would visit local streets a number of times each day. Milk was not delivered in bottles but was measured out into jugs or metal containers.

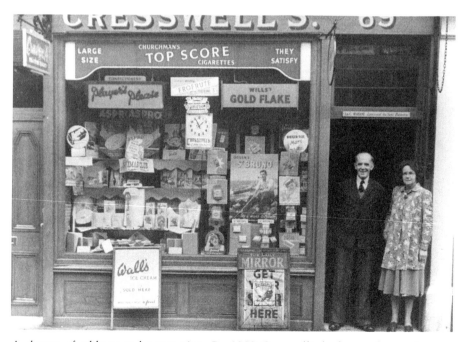

A change of address and occupation. By 1950 Cresswell's had moved next door to 69 Kingsgate Road and had become a tobacconist. The growth of large companies delivering milk to the doorstep led to many small dairies closing down.

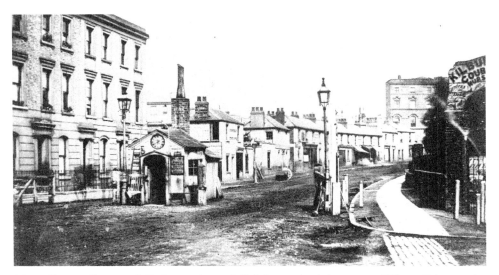

The Kilburn toll gate, 1860. It was situated slightly north of the present Kilburn Priory, at its junction with Kilburn High Road. Goubest, nurseryman, had his shop on the right, which was still there in the 1890s.

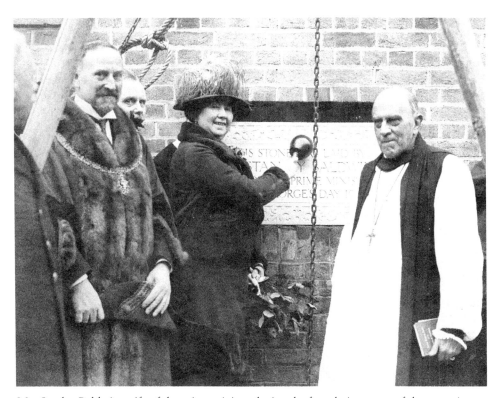

Mrs Stanley Baldwin, wife of the prime minister, laying the foundation stone of the extension to the Hampstead Health Institute, Kingsgate Road, 23 April 1929. In attendance were the Mayor of Hampstead, Alderman W.C. Northcott, and the Bishop of Willesden, Dr W.E. Perrin.

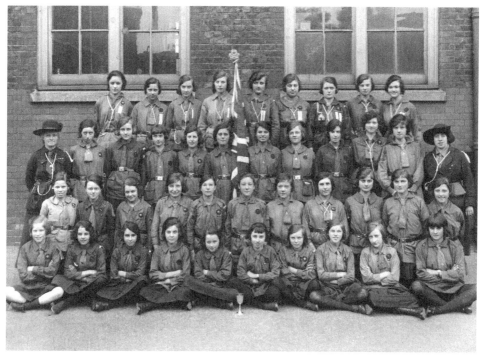

The 2nd Hampstead Company of Girl Guides, June 1923. I would be delighted to hear from you if you can identify any of the Guides or know where the photograph was taken.

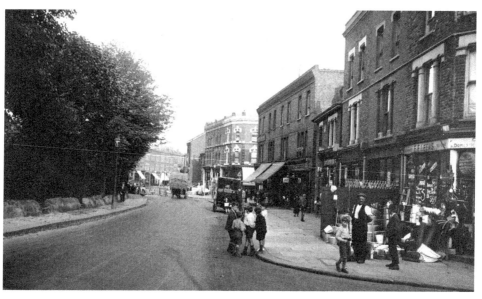

Mill Lane looking east from Broomsleigh Street, c. 1925–7. Ernest Edward Leeks, domestic stores, has now been replaced by Glass Art Shop.

SECTION FOUR

BELSIZE PARK
TO GOSPEL OAK

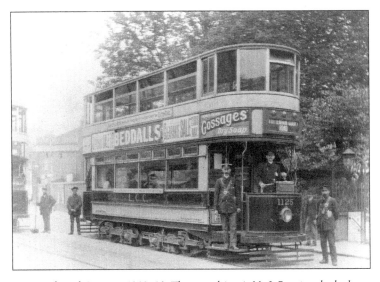

*South End Green, c. 1909–10. The tram driver is Mr J. Pearce, who had
worked the route since 1899 on the horse-drawn trams. He died in service
in 1941. The line was electrified on 10 September 1909. The class E/1
tram is advertising a sale at Beddalls, linen-draper, in Kentish Town Road.*

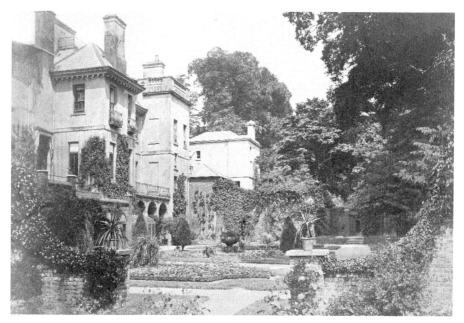

Rosslyn House, Lyndhurst Road, *c.* 1880. This was one of the grand local houses. The last resident was Charles Woodd, a wine merchant, and in 1891 he was here with his wife, three daughters, nurse, cook, housemaid, undermaid, kitchen maid, butler and a page boy, while seven other servants lived in the grounds. Following Woodd's death in 1893, the house was demolished in 1896.

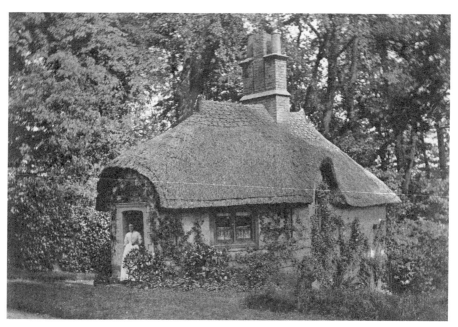

Garden Cottage in the grounds of Rosslyn House, 1880. Here lived the gardener Mr Shepherd and his laundress wife, together with an undergardener.

Right: Ivy Bank, 1890s. It stood between Belsize Lane and Ornan Road. Sir Arnold Bax, the composer, lived here from 1893 to 1911.

Below: George Reed, ironmonger, 10 Belsize Parade, *c.* 1912–13. The shop was still used as an ironmonger's in the 1970s, though it has now been renumbered as 183 Haverstock Hill, on the corner of Glenloch Road, and is occupied by B. and R. Carpet Co. The attractive windows have been preserved.

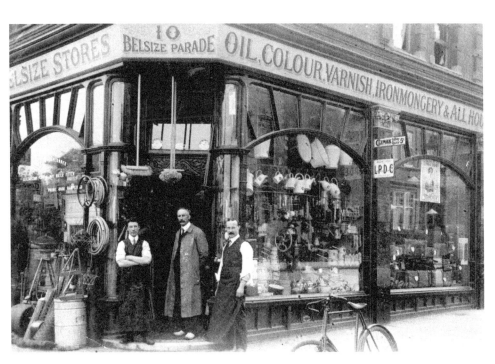

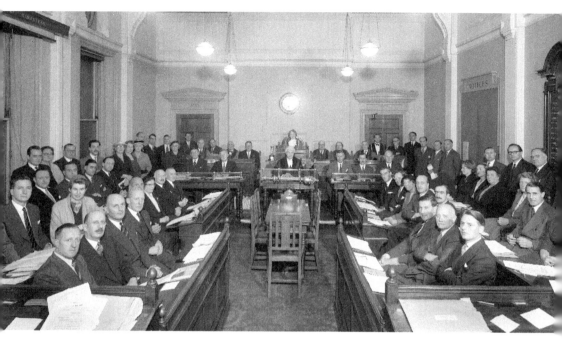

Hampstead Borough Council meeting in the council chamber of Hampstead Town Hall, May 1956. The mayor is Councillor Miss D.R. Bailey and sitting in front of her is the town clerk, Philip Harold. In the picture are two councillors who have also served on Camden Council since it was formed in 1965. On the left, second row seated, first on the left is Cllr Julian Tobin, and on the right, in the back row, third from the right, wearing glasses, is Cllr Roy Shaw. Hampstead Town Hall was designed by Kendall and Mew and opened without ceremony in June 1878, although 1877 is carved on the front. Its future is undecided, although lottery funds have been approved for a feasibility study on potential uses.

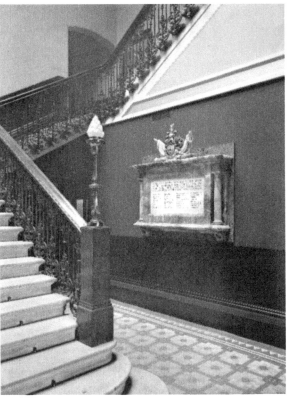

Right: A photograph dating from the 1920s, showing the staircase at Hampstead Town Hall and the memorial to council staff who died in the First World War.

Below: Hampstead Town Hall, Haverstock Hill, *c.* 1902. The lodge on the left of the picture was the entrance to Hillfield, one of the large houses on Haverstock Hill. John Constable painted a picture of the house with sheep in the grounds. Hillfield Court was built on the site in the 1930s.

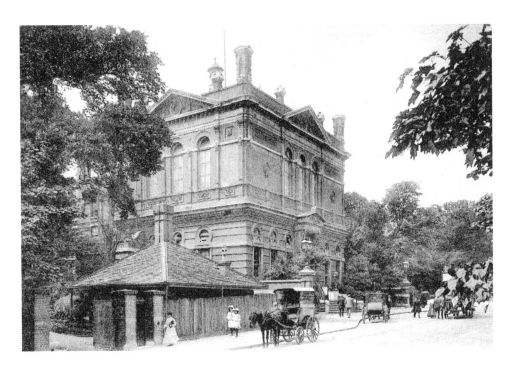

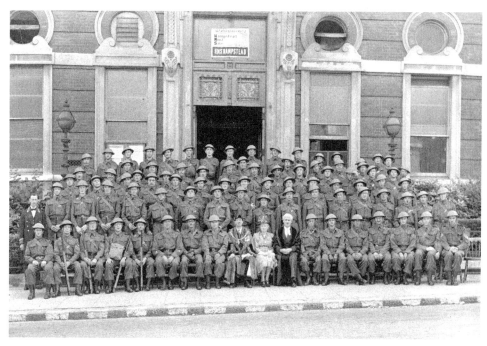

Hampstead Home Guard outside the Belsize Avenue entrance to Hampstead Town Hall during War Weapons Week, 17–24 May 1941.

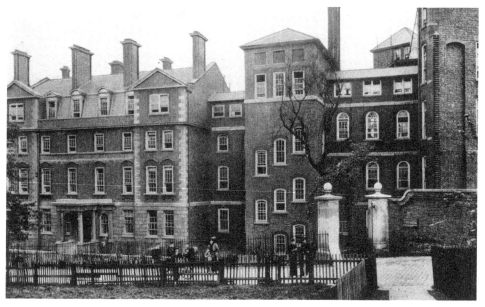

Hampstead General Hospital, c. 1905. The Royal Free Hospital moved to this site from Gray's Inn Road and the main block was opened in 1974. Hampstead General Hospital was demolished in 1975 and the site used for car parking and a garden. The rest of the Royal Free was completed in 1978, when it was officially opened by the Queen.

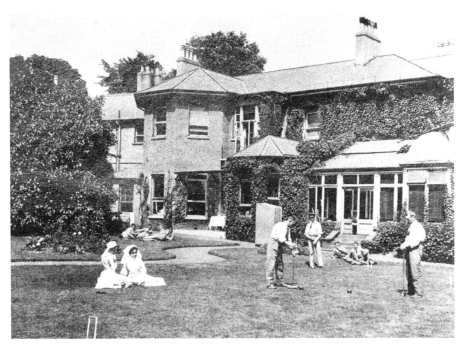

Rosslyn Lodge Auxiliary Hospital, Lyndhurst Road, was opened by the Hampstead
Red Cross in the summer of 1916. Money for equipment and for making the house fit
to receive soldiers had been raised by appeals and a flag day. It closed in 1919 having
treated 2,227 patients in its 104 beds without any deaths.

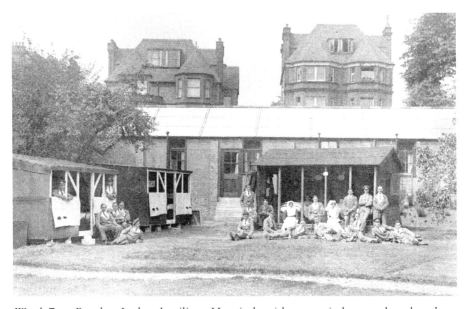

Ward 7 at Rosslyn Lodge Auxiliary Hospital, with open-air huts and asylum hut.
Rosslyn Lodge is now the Olave Centre for the World Association of Girl Guides and
Girl Scouts. Housing in Waterside Close built in its grounds.

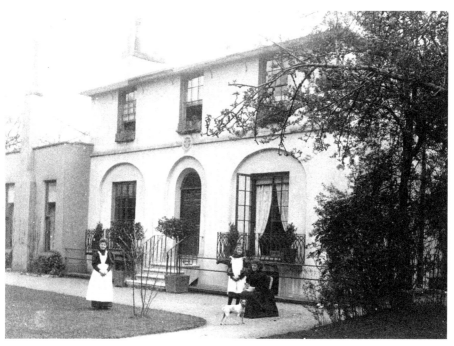

Keats House with Mrs Ell, her daughter and maid, 1896. John Keats lived here from 1818 to 1820 and composed his 'Ode to a Nightingale' in the garden. The house was rescued from demolition by public subscriptions and handed over in trust to Hampstead Borough Council, which opened it to the public in 1925.

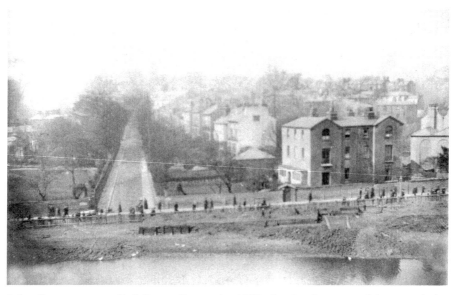

John Street, now called Keats Grove, in 1870. In the foreground is one of the Hampstead Ponds which was filled in during 1892 following complaints about its polluted state.

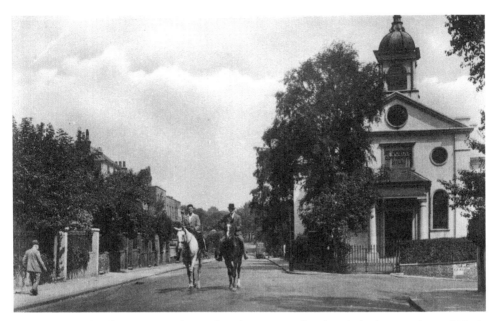

Downshire Hill, showing St John's Church, 1940s. The church had opened in 1823. It became a proprietary chapel, owned by members of the congregation. It is now the last privately owned church of its type in London.

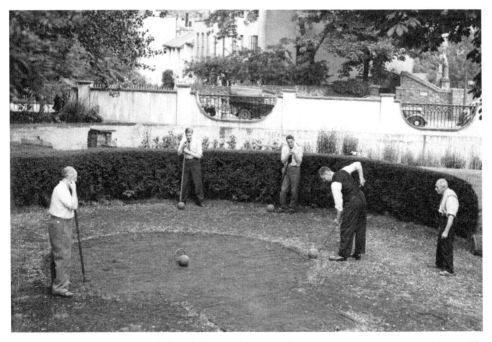

A game of pell mell or lawn billiards being played at the Freemasons' Arms, Downshire Hill, in 1946. The game was introduced to this country in the seventeenth century and was a cross between croquet and billiards, played with four 8 lb balls and cues with hoops through the end.

Belsize Park, eastern coppice and boundary, 1860. The view is looking across where Glenilla Road and Howitt Close now stand.

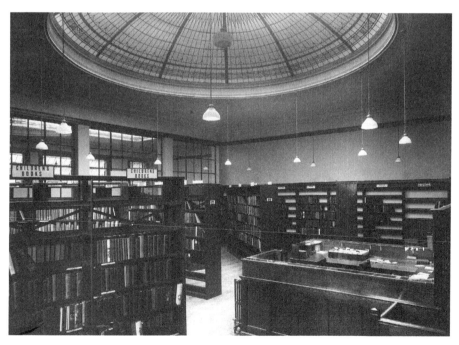

Heath Branch Library, July 1931. It opened in the gardens of Keats House, and the size and style of the exterior was designed to blend in with the house. Part of the building was designed as a Keats Museum and Keats Memorial Library, but a children's library was created within the room in 1951.

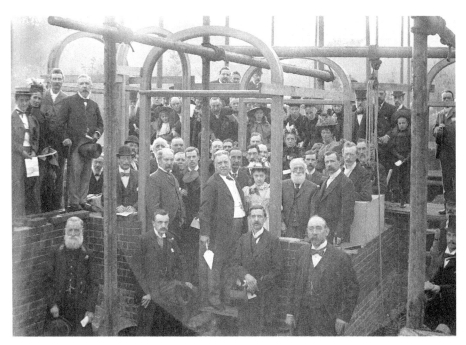

The foundation stone being laid at Belsize Library, Antrim Grove, 10 August 1896, by Dr Charles Ryalls, Chairman of the Public Libraries Committee.

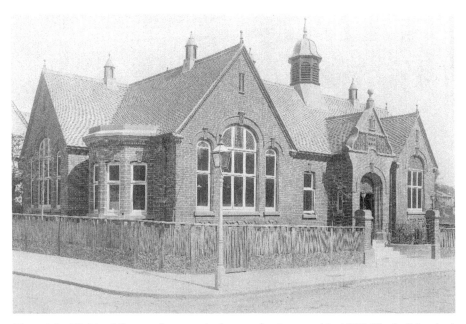

The original Belsize Library, photographed soon after it opened in 1897. The building had been designed by the surveyor, Charles Lowe, and the librarian, W.E. Doubleday, and the vestry was very pleased that it had saved architects' fees. Unfortunately, structural defects were later found in the building and it was closed. A new one was erected in 1937.

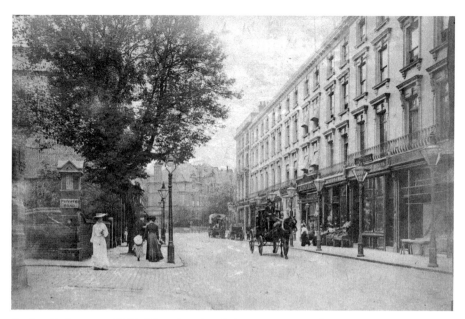

England's Lane, *c.* 1900. The view is of the entrance to the private road, Chalcot Gardens, looking towards the Washington pub. The buildings with their balconies are still intact today, apart from the shop fronts. Allchin and Co., chemist, a long-established business on the corner of Primrose Hill Gardens, is worth a visit to see some of its original features.

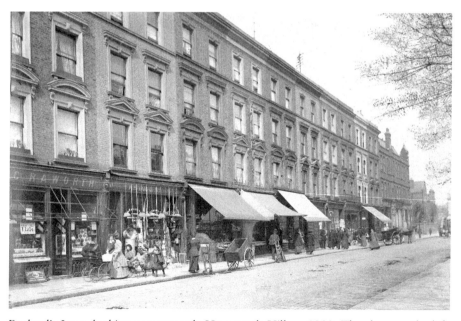

England's Lane, looking east towards Haverstock Hill, *c.* 1900. The shop on the left – Louis Carl Raworth, cheesemonger – is now occupied by Jenny Jordan, hair, makeup and beauty shop.

Belsize Park Gardens, looking north from the Washington pub, *c.* 1904. The cart of Boote and Davis, cheesemongers, has travelled from their shop at 107 Cannon Street in the City. The house on the left was 2 Eton Avenue, now covered by Lowlands flats. The garden walls further along are now the site of 83–9 Belsize Park Gardens.

Steele's Road at its junction with Fellows Road, 1904. The street was named after the writer Sir Richard Steele, who had lived on the west side of Haverstock Hill, 1712–13. The cottage was pulled down in 1867 to construct the entrance to Steele's Road.

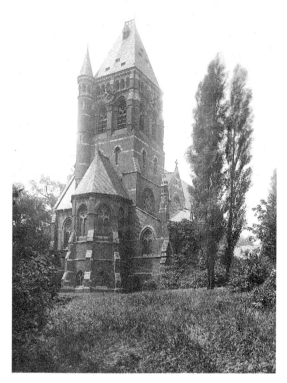

Left: St Stephen's Church, Rosslyn Hill, *c.* 1890s. It was built in 1869–73 at a cost of £27,000. The architect was S.S. Teulon, who considered this his finest work, although it has been described as 'half House of God, half castle on the Rhine'. It closed in 1977 but has been restored by the St Stephen's Restoration and Preservation Trust as a public venue.

Below: View up Haverstock Hill, pre-1915. The road on the left is Englands Lane, and Stanbury Court now stands on the south corner. Nos 118–20 Haverstock Hill, the houses on the right, have recently been extensively restored.

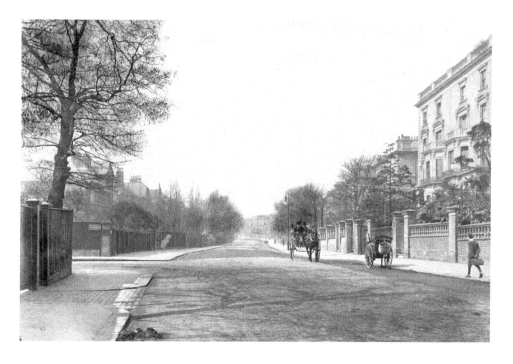

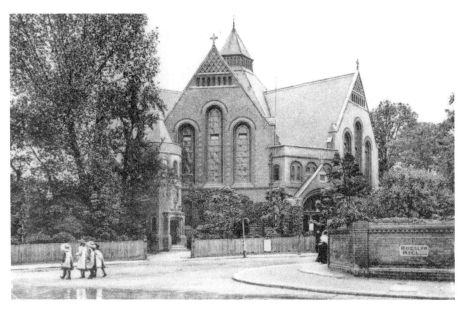

Lyndhurst Road Congregational Church, 1906. The church, designed by Alfred Waterhouse, still stands on the corner with Rosslyn Hill but the last service was held on 1 April 1978. The property was then converted into flats and the hall was used for a variety of artistic events. More recently the building has served as a recording studio.

Belsize Grove, looking towards Belsize Park Gardens, 1870. Most of the grand houses in the street have since been replaced by blocks of flats. Straffan Lodge, built 1969, is now on the right, past no. 5, and Manor Mansions was built on the right corner in 1884.

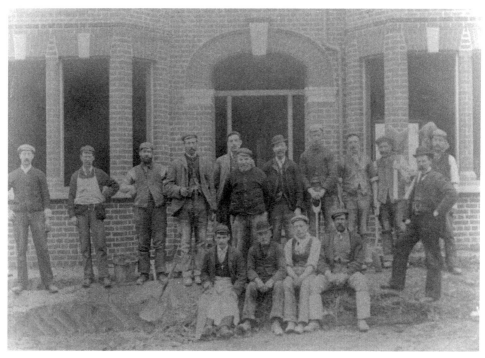

Workmen outside 3 and 5 Heathhurst Road, during construction, 1897. In the centre, with the beard, is Henry Edward Bland, and behind him, holding a clay pipe, is his son, also called Henry.

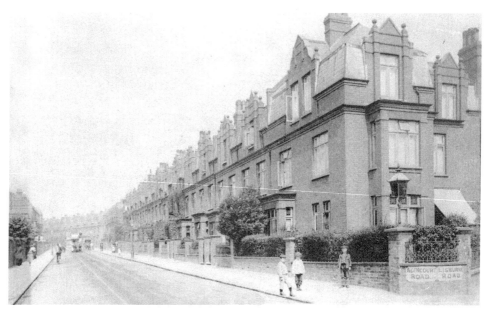

Agincourt Road, *c.* 1905. In the distance is a horse-drawn tram heading south, the direction of the current one-way system. A zebra crossing is now in the foreground and fully grown trees line the street.

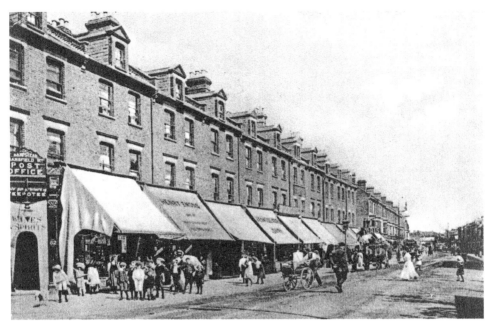

Mansfield Road, looking east from Courthope Road, *c.* 1906. The post office on the left is now empty.

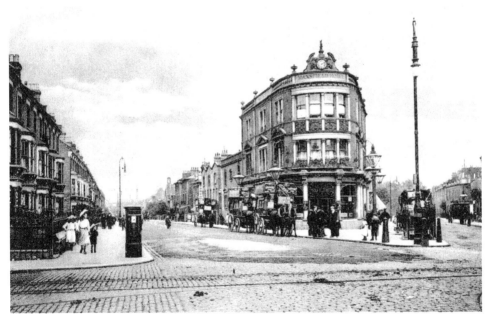

Mansfield Hotel, Mansfield Road, *c.* 1907. In the foreground can be seen the tram line for the horse-drawn trams from South End Green, heading south. The hotel, and Lismore Road to its right, have now been replaced by Waxham flats on the south side of Mansfield Road.

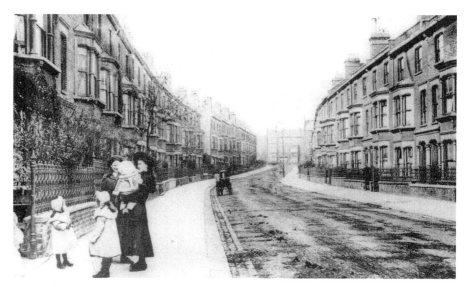

Roderick Road, *c.* 1905. Part of it was built in 1879 but the derivation of the name is unknown, possibly associated with the builder. This is one of a series of local street scenes published around 1904–7 by Charles Martin, which include even the most unassuming terraced houses, often notable by the absence of parked cars.

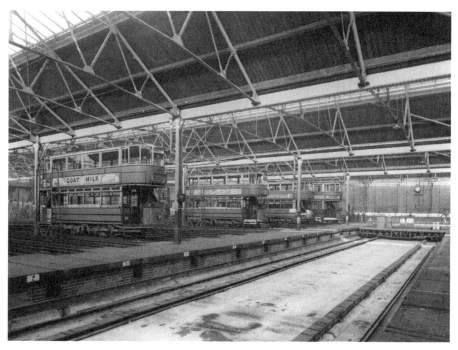

Hampstead Tram Depot, Cressy Road, 1936. It was originally built as a depot for horse-drawn trams for the London Tramways Co., then used by the London County Council. It was rebuilt for electric trams after the line was electrified. After its closure it was used for a period as a garage for British Road Services and was finally demolished in late 1994. Byron Mews has been built on the site.

SECTION FIVE

SWISS COTTAGE

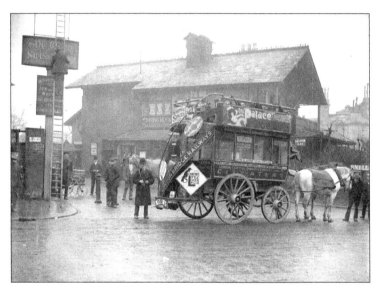

*Changing horses at the Swiss Cottage Tavern, c. 1902. Working a
pair-horse bus normally involved a stud of eleven horses, of which one
worked round as a relief. The buses averaged 60 miles a day and the
horses 12 miles a day.*

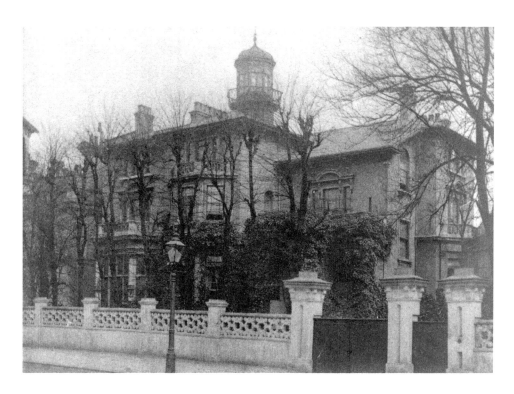

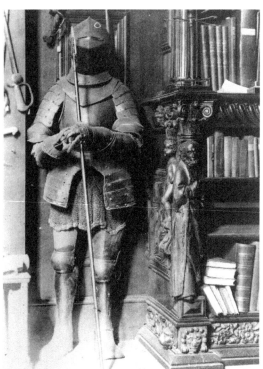

Above: Park House, St John's Wood Park, the Gardner family home, *c.* 1900. The maids' rooms were at the top of the house and the tower was used as a play room for the daughter Mabel. The family also used it to watch Zeppelin raids over London during the First World War.

Left: Suit of armour in the library of Park House, *c.* 1900. The house had no gas or electricity: only candles were used.

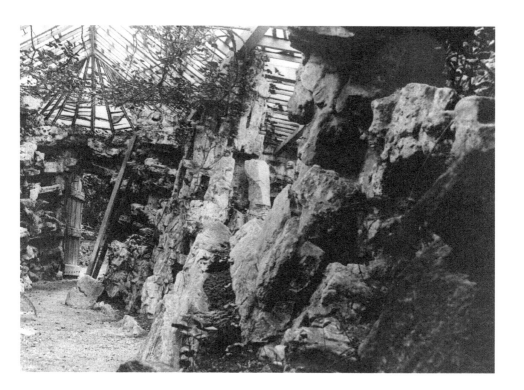

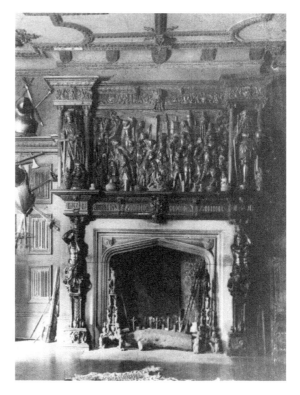

Above: Grotto in the grounds of Park House, *c.* 1916. It had a large garden with two grottos and was maintained by two gardeners before the First World War but afterwards by only one. The family left the house in 1929 and Park Lodge was later built on the site.

Right: The library in Park House, showing the fireplace with overmantle 'Entry into Jerusalem', *c.* 1900. The room contained the famous Gardner Collection of topographical items on London, collected by John Edmund Gardner, who had hired artists to record old buildings. His son Edmund sold it in 1910, and it was later auctioned in 1923. There were 50,000 items, of which 8,000 to 9,000 were paintings and drawings.

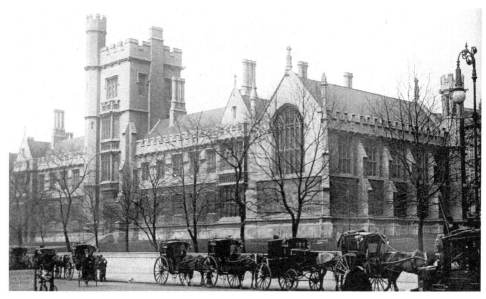

New College of Independent Dissenters, Finchley Road, *c*. 1909. The 240 ft long building, in an early Tudor style, was designed by J.T. Emmett and opened in 1851 as a training college for ministers. In 1934 it was demolished and replaced by Northways flats and College Parade.

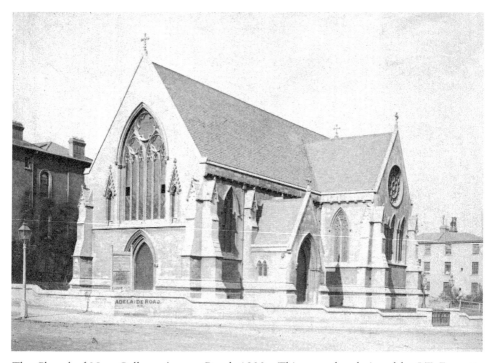

The Chapel of New College, Avenue Road, 1890s. This was also designed by J.T. Emmett. Later used to store stage scenery, it caught fire just before it was due to be pulled down in 1960. It is now the site of Swiss Cottage Library.

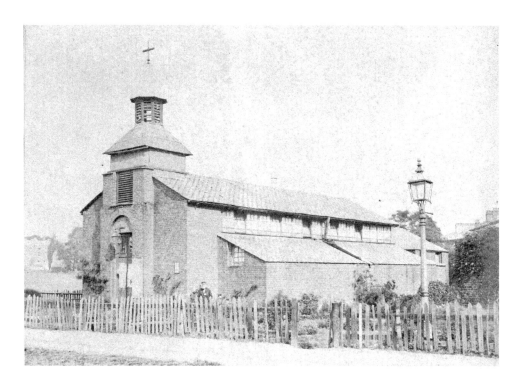

Above: Temporary Mission Hall and School on the corner of Belsize Lane, 1875. It was demolished when Fitzjohn's Avenue was constructed through the site in 1875.

Right: St Paul's Church, Avenue Road, *c.* 1900. S.S. Teulon's designs are considered to be highly original, and this 1859 church was certainly a flamboyant creation. It was bombed in 1940 but the ruins were not finally demolished until 1958. The Polygon flats were built on the site in 1962.

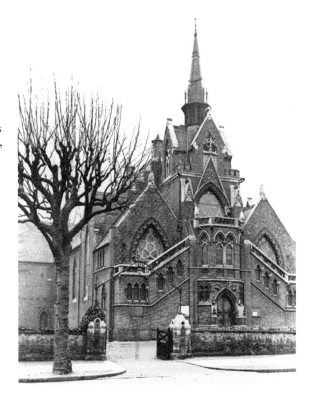

This photograph was taken from 53 Belsize Park, showing its garden and, on the left, the temporary Mission Hall in Belsize Lane, 1870s. The track in the background became the route of Fitzjohn's Avenue when the land was sold off for building in 1875.

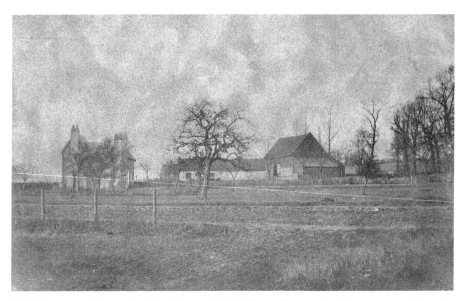

Toll house and barn, Belsize Lane, 1860. The toll gate had been erected by the landowner to control access over his land. The view is looking north from near where Lancaster Grove now stands. The bottom of Daleham Mews is the site of the barn, and the toll gate stood nearby on Belsize Lane.

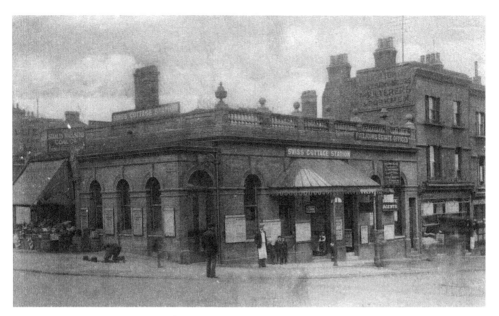

Swiss Cottage station, corner of Belsize Road, *c*. 1905. The Metropolitan and St John's Wood railway opened here on 13 April 1868. For the Bakerloo (now Jubilee) line, which opened here in 1939, a new station had been constructed underground. The Metropolitan platforms closed in 1940 and Cresta House was built on this site in the 1980s.

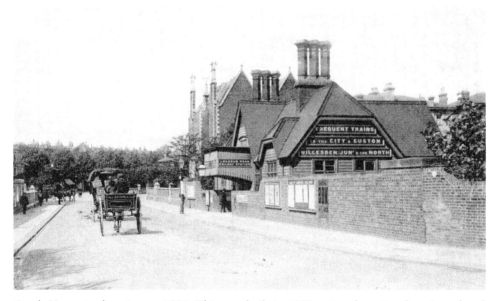

South Hampstead station, *c*. 1904. This was built in 1879 as Loudoun Road station, closed in 1917 as a wartime measure and reopened as South Hampstead on 10 July 1922 for the new electrified Watford–Euston service. It was rebuilt following a fire in 1968.

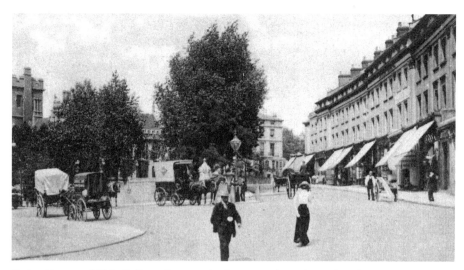

Swiss Cottage, 1904. College Crescent is shown to the right and in the centre, partially hidden behind the trees. All the shops and buildings on the right have been demolished and the Central School of Speech and Drama has recently extended on to it. Finchley Road curves to the left. The view was taken looking north from Belsize Road, now closed at this point.

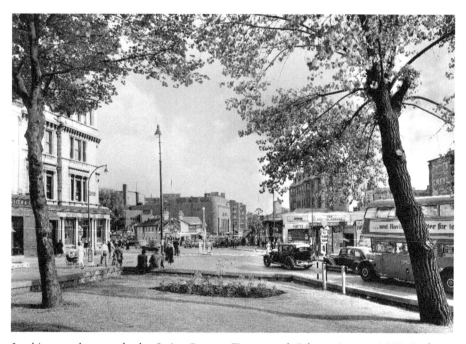

Looking south towards the Swiss Cottage Tavern and Odeon cinema, 1952. In front of the pub was the Swiss Cottage Dairy, which was pulled down in about 1964. The National Provincial Bank on the left was demolished, and the site is now used by the Central School of Speech and Drama. On the right Cresta House and Centre Heights now tower over Finchley Road.

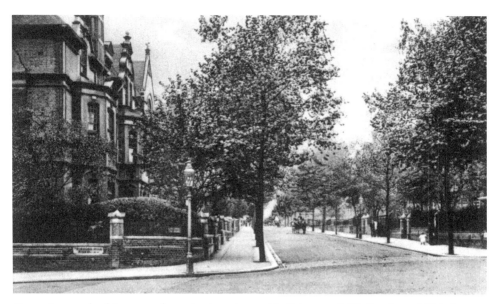

Eton Avenue looking east from its junction with Primrose Hill Road, *c.* 1906. It was developed between 1886 and 1894 with large houses, many of which used stabling for their carriages and horses in Eton Stables (now Eton Garages).

Samuel Palmer, a founder of Huntley and Palmer biscuits, lived at 40 College Crescent for twenty-one years until his death in 1903. In 1904 his family presented this drinking fountain at the corner of Fitzjohn's Avenue. It is seen here in about 1906. Following extensive restoration it was reopened on 8 October 1994 by Samuel's great-grandson, William Palmer.

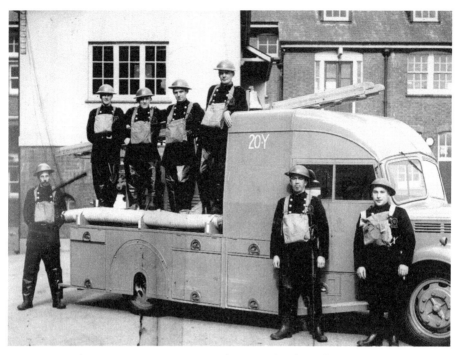

Wartime Auxiliary Fire Service engine in the grounds of South Hampstead School for Girls, Maresfield Gardens, in the 1940s.

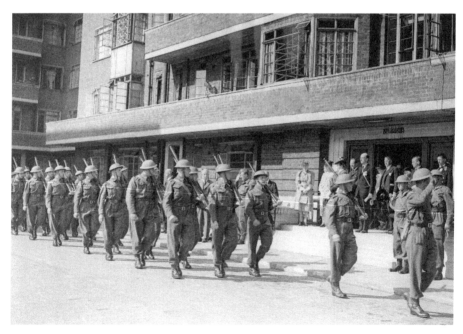

Hampstead Home Guard on parade in the courtyard of Regency Lodge, Adelaide Road, 1940s.

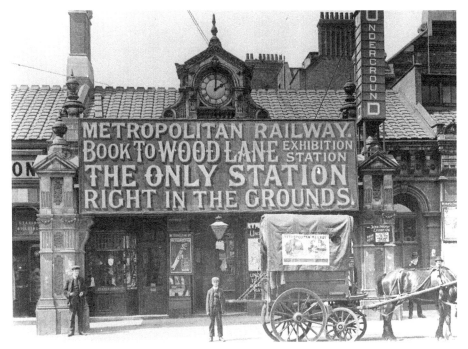

Finchley Road station, with a Metropolitan Railway delivery cart in front, 1910. The Japan–British Exhibition opened at Shepherd's Bush on 14 May 1910 under the auspices of the Imperial Japanese Government. Wood Lane station, on the Hammersmith and City line, was later called White City; it closed on 25 October 1959.

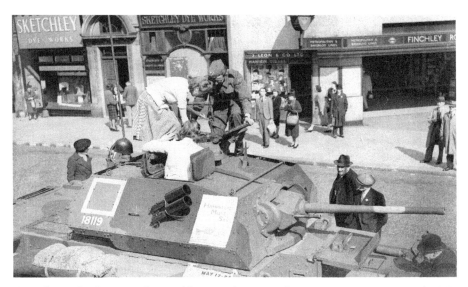

A tank on display outside Finchley Road station during War Weapons Week, 17–24 May 1941. Under the theme 'HMS *Hampstead*' it was part of the effort to raise enough money to buy one or more destroyers for the Battle of the Atlantic. The sum of £697,460 was raised in Hampstead but, alas, no ship was named HMS *Hampstead*.

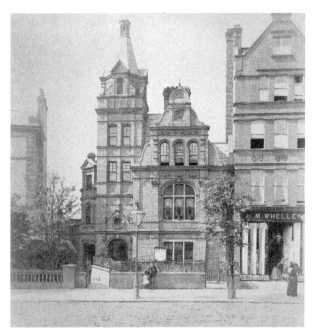

Left: Hampstead Public Baths, Finchley Road, 1888. The tower contained cisterns for supplying water to the baths. It closed in 1964 when Swiss Cottage Baths opened, and was a warehouse until destroyed by fire in 1972. Sainsbury's supermarket opened here in 1973, later used by Woolworths and currently empty.

Below: Hampstead Public Baths, showing the dressing rooms, 1888. There were two pools for men (first and second class), one for women and twenty-four private baths. An additional pool for women opened in 1891.

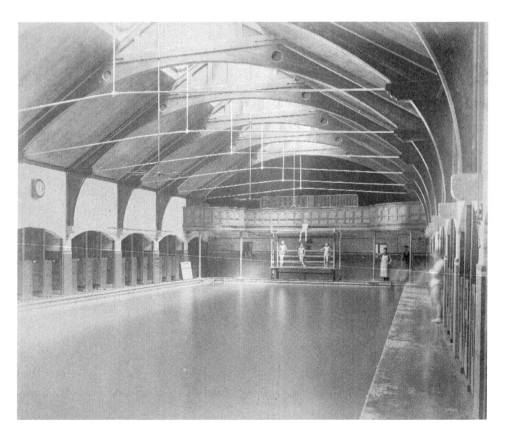

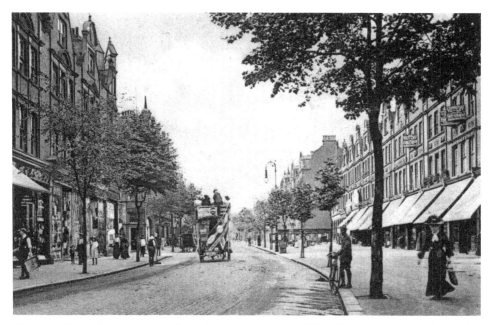

Finchley Road, looking north from Rosemount Road, 1904. The horse-drawn bus is by Lithos Road. Most of the buildings still remain, after some alterations.

Finchley Road, showing a horse-drawn bus and taxi, 1905.

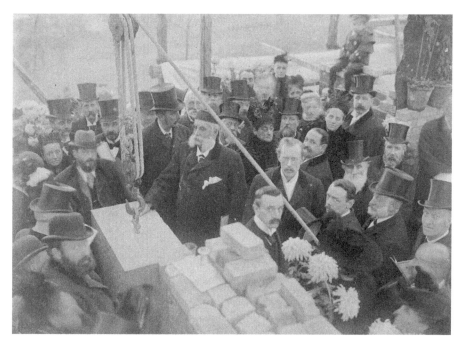

Henry Harben laying the foundation stone of Hampstead Central Library, 10 November 1896. He gave £5,000 as a gift to cover the entire cost of the building.

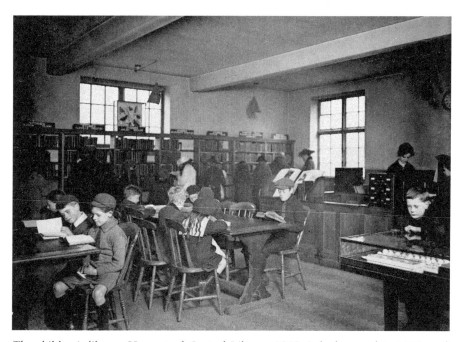

The children's library, Hampstead Central Library, 1918. It had opened in 1909, and was one of the first children's libraries in the London area. It had a separate entrance in Arkwright Road.

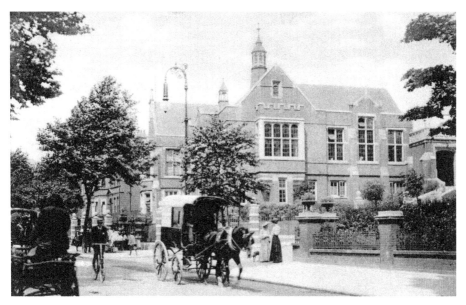

Finchley Road outside Hampstead Central Library, 1905. The library was designed by Arnold S. Tayler. It closed in 1964 when the Swiss Cottage Library opened, and reopened as the Camden Arts Centre in 1966.

The Misses Hampton's girls' school and kindergarten at Belgrave, 53 Broadhurst Gardens, in 1901. The photograph was taken in the back garden, which acted as the school playground. F. Gordon Roe, the small boy in the front row, started at the school in 1901 and was sure that this was the sole occasion on which he handled any cricketing apparatus while at the kindergarten.

Canfield Place, *c.* 1900. It was built as mews and livery stables for Canfield Gardens and surrounding streets. Most people did not keep their own horse transport but would hire for specific needs or use public transport. Goods were delivered to the door by most shops at that time.

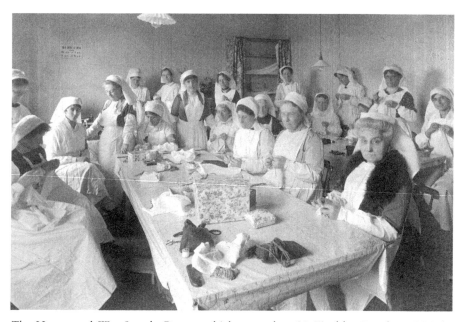

The Hampstead War Supply Depot, which opened at 91 Finchley Road on 15 July 1915. The volunteers produced bandages, bed jackets, pyjamas and swabs needed for war hospitals overseas. Langhorne Court now covers the site.

SECTION SIX

PRIMROSE HILL
& CHALK FARM

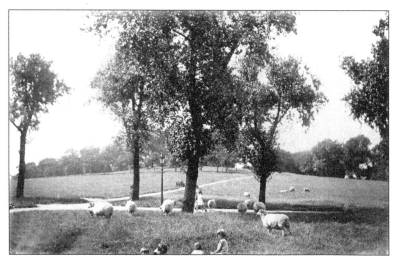

*Sheep on Primrose Hill, c. 1905. During the Second World War some of the
open space was turned into allotments as part of the war effort to save on
imported food. Guns and searchlights were also placed on the hill.*

Primrose Hill was originally owned by Eton College. When it was developing its London estate it arranged the exchange of this land for Crown land near the college in Berkshire. The land was reserved as a park by an Act of Parliament of 1842.

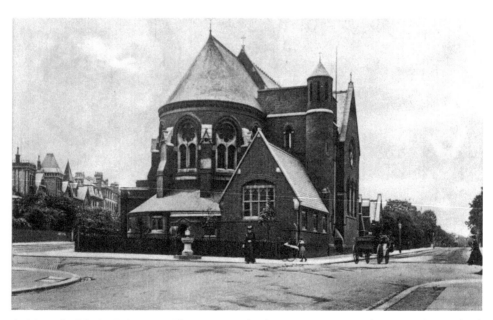

St Mary-the-Virgin, Primrose Hill, *c*. 1904. The first part was erected in 1872 by Michael Manning, a member of the congregation, in an early French Gothic style. Percy Dearmer, the vicar from 1901 to 1915, made it a showpiece of liturgical worship and good music.

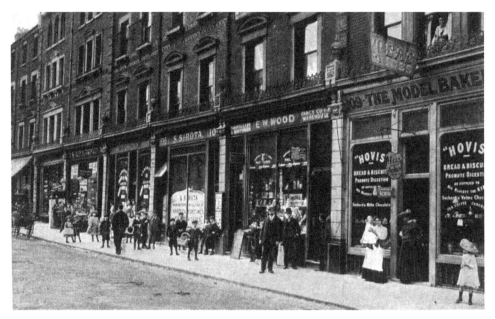

Nos 103–9 Regent's Park Road, *c.* 1905–7. The Model Bakery at no. 109 was later used as a public library from 1947 to 1961, before it moved to a new building in Sharpleshall Street.

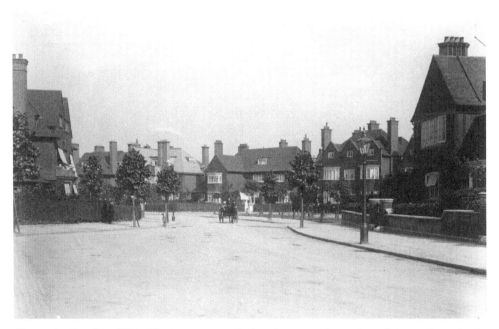

Elsworthy Road, *c.* 1904. The houses were designed as an early version of the garden suburb, with wide pavements, trees and privet hedges. All is still there today but the trees are fully grown. The view is from Wadham Gardens (just out of the picture, to the left), looking east.

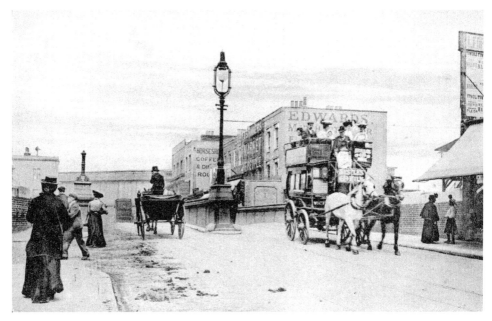

Chalk Farm Road, *c.* 1905. The view is looking north over the Regent's Canal bridge. Camden Lock is on the left.

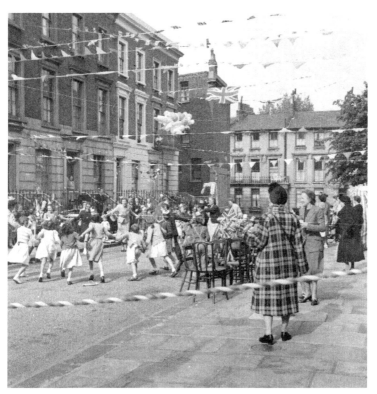

Rothwell Street, off Regent's Park Road, 1953. This was one of the many street parties that took place in the locality to celebrate the coronation of Queen Elizabeth II.

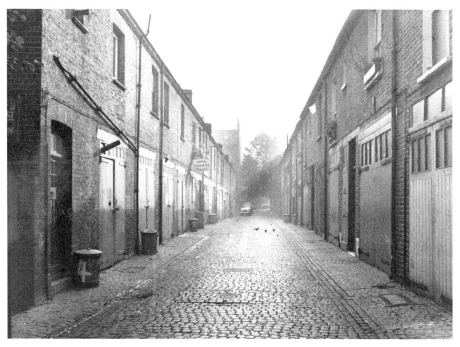

Oppidans Mews, 1965. Oppidans was the name used for the town students of Eton College, which owned land in the area. The mews provided stabling for the nearby streets, which were laid out in the 1860s. Meadowbank flats have been built on the site between Oppidans and Ainger Roads.

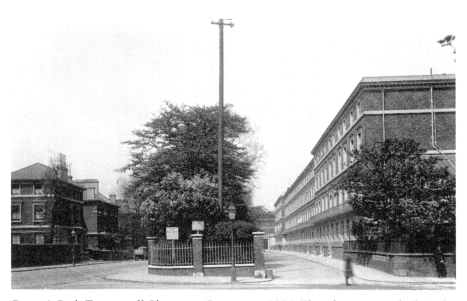

Regent's Park Terrace, off Gloucester Crescent, *c.* 1906. These houses were built in the 1840s and have still retained their attractive ironwork balconies. The road on the left of the picture is Oval Road.

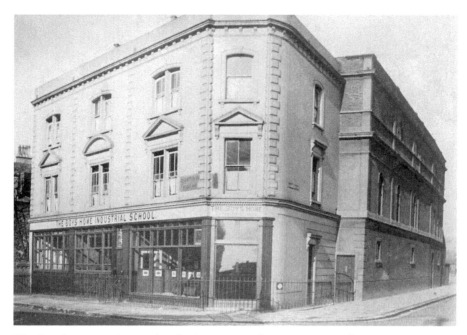

The London Boys' Home for the Training and Maintenance of Destitute Boys not Convicted of Crime, on the corner of Regent's Park Road and King Henry's Road, c. 1890s. It had moved here in 1865. By 1890 it could accommodate 150 boys. It closed in 1920 and this building is now the Chesterfield flats. The Boys' Home chapel is now 109A–D Regent's Park Road.

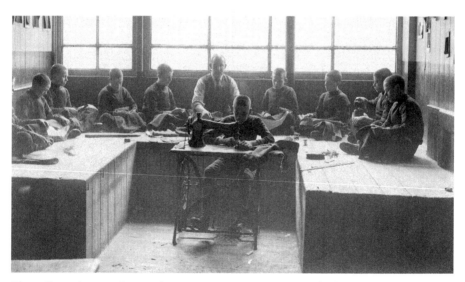

The tailors' shop at the London Boys' Home, c. 1890s. In the background the master tailor is sitting cross-legged, as was usual for tailors, with the boys copying. Some of the boys would have progressed with tailoring as a trade, the rest would have learned enough to repair and maintain their own clothes. Sewing was done entirely by hand until this machine was acquired in 1890.

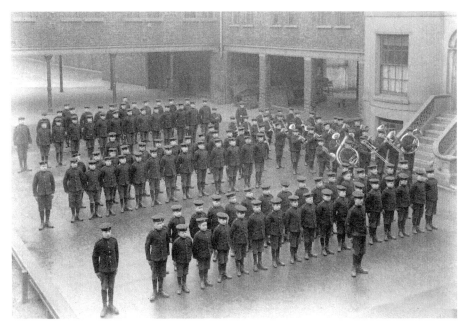

A parade at the London Boys' Home, *c.* 1890s. The band was a popular feature of the school and would often be hired out to perform at garden parties, sports events or even London Zoo.

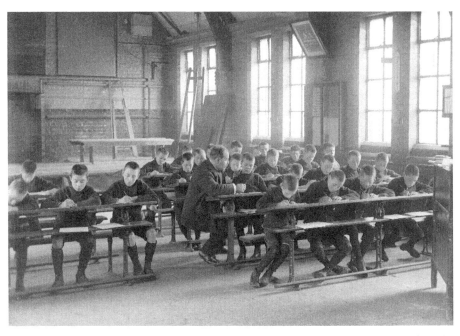

Lesson time at the London Boys' Home, 1890s. There was a balanced regime of work, learning and schooling. The boys could also be hired for housework from 7 to 8.30 a.m. and on Saturdays from 4 to 5.30 p.m.

ACKNOWLEDGEMENTS

The author is grateful for the loan of postcards and photographs from the following: Mrs C. Austin, Paul Barkshire, Mrs E. Butler, Roger Cline, Nicky Hillman, London Transport Museum, Museum of London, Christopher Oxford, John Smith. However, the majority of the pictures come from the collections of the London Borough of Camden Local Studies and Archives Centre.

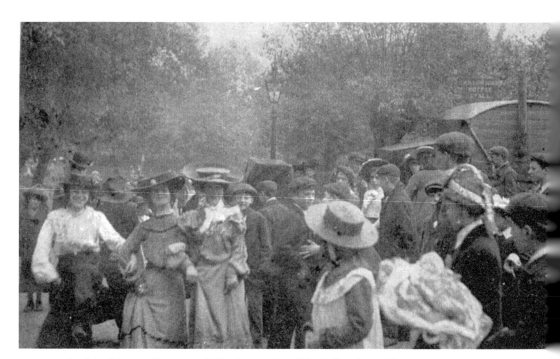

Bank holiday on Hampstead Heath, near East Heath Road, *c.* 1904.

Other titles published by The History Press

The City of London
BRIAN GIRLING

This book paints the fascinating picture of the events and people which helped shaped the city we know so well today, including the building and wartime destruction of some of its characteristic features.

£12.99 978 0 7524 5935 7

Little Book of London
DAVID LONG

Sue Barker, *Publishing News*, July 2007: 'A coruscating compendium of wacky facts, *The Little Book of London* from David Long may be little in size but it's big on information and my favourite trivia read this year.'

£9.99 978 0 7509 4800 5

Haunted London Underground
DAVID BRANDON

Spooky sightings and strange occurrences on London's busy underground network.

£9.99 978 0 7524 4746 9

Visit our website and discover thousands of other History Press books.

www.thehistorypress.co.uk